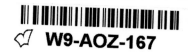
THEN & NOW

ALBANY

*This book is dedicated to
Nancy, Chris, Kevin, Jackson,
Jennifer, and Jason.*

This political cartoon is entitled "Albany's Historic Preservation Policy."

Then & Now
ALBANY

Don Rittner

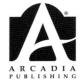

ARCADIA
PUBLISHING

Published by Arcadia Publishing
Charleston SC, Chicago IL, Portsmouth NH, San Francisco CA

Printed in the United States of America

Library of Congress Catalog Card Number: 2002111904

For all general information contact Arcadia Publishing at:
Telephone 843-853-2070
Fax 843-853-0044
E-mail sales@arcadiapublishing.com
For customer service and orders:
Toll-Free 1-888-313-2665

Visit us on the Internet at www.arcadiapublishing.com

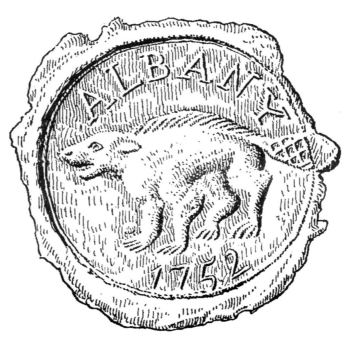

The second official Albany seal was probably designed to observe the 100th anniversary of the founding
Beverwyck, the village that became Albany. The current year, 2002, is the 350th anniversary of that founding.

CONTENTS

ACKNOWLEDGMENTS

As always, many people were instrumental in helping me with this work. My greatest appreciation goes to my longtime friend John Wolcott, who never lets me stray from the truth. His passion for saving history easily rubs off onto others. Additional thanks for the use of images go to another longtime friend, Morris Gerber, and to Chris Milian for use of the beautiful photograph of Albany from the air, the last image in the book. Others who helped include Philip Galka; David M. Hernahan; Rev. William Pape; Ellen K. Gamache and the Albany Public Library; Kara, Nina, Roger, and Rusty; Greta Wagle; Lou Ismay, the 27th Air Division; and Pam O'Neil of Arcadia for her patience.

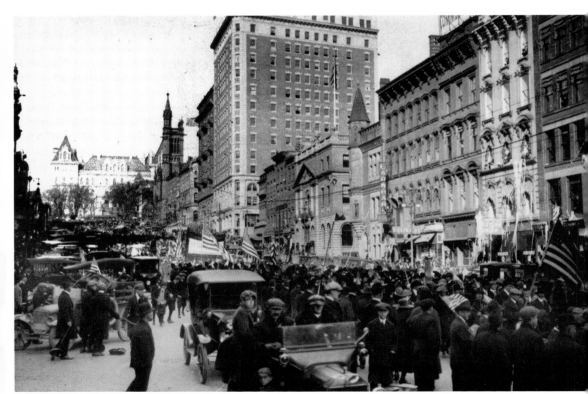

Albanians celebrate the end of World War I and the return to prosperity before the advent of another kind of war: suburban growth and the resulting demise of Albany's downtown.

INTRODUCTION

Albany, the capital city of New York State, is one of the oldest settled regions in the United States. The year 2002 marks the 388th anniversary of Albany's origins in 1614 as a Dutch fur-trading fort along the west bank of the historic Hudson River. The year also marks the 354th anniversary of the permanent settlement of Beverwyck (1648), which became Albany, the 350th anniversary of Beverwyck's being chartered as a village (1652), and the 316th anniversary of Albany's being chartered as a city (1686). Very few American cities can boast a history as long or as interesting.

Albany is located 150 miles north of New York City and rests on the floodplain of the Hudson River at sea level. Here, the river is an estuary, still part of the Atlantic Ocean, until it reaches Troy, just a few miles north of the city on the river's eastern shore. Albany rises above the floodplain and spreads west for several miles on plains formerly occupied by rich pine barrens. Albany has been called the "City on the Pine Plains."

When Henry Hudson reached the Albany area with his crew in 1609, he remarked on what a beautiful area it was. Albany is surrounded by picturesque views. To the west of the city rises the Helderberg Escarpment, some 1,600 feet above sea level, and the Catskill Mountains beyond that. To the east are the Rensselaer Escarpment, Taconic Mountains of Massachusetts, and Green Mountains of Vermont. To the north lie the ancient Adirondacks.

Even the political borders of the city fall on rich and diverse natural areas. The northern boundary includes the Patroon Creek Valley and Tivoli Hollow. The western side includes several hundred acres of pine barrens, with many endangered plants and animals. At the southern border is the Normanskill Valley, still primarily wild and undeveloped. On the eastern side is the Hudson River.

Albany is a city with nearly four centuries of history, which preservationists and environmentalists have battled to save. Activists of the 1970s preserved the pine barrens on the west (the Pine Bush), now enjoyed by many. The city has also tried to reclaim its historic riverfront by creating a preserve and constructing a new $9 million pedestrian bridge over the multilane highway that cut off the city from the Hudson in the 1970s.

However, historically the city has not been kind to its rich natural and human heritage. Very few standing structures of Dutch culture remain, and natural areas are constantly being eyed for development. The desire to accommodate the automobile culture during the late 20th century was an overriding factor in the loss of the city's historic and archaeological treasures. In the process, not only individual historic buildings but also entire neighborhoods were erased to accommodate plazas and parking areas for suburban commuters and their vehicles.

Archaeological treasures have been excavated and then covered again by new buildings or parking facilities. For example, in 1970, the original Fort Orange was discovered by historian John Wolcott and others. After partial excavation, it was covered by an Interstate 787 off-ramp. Certain government and business leaders actually promoted the burying of such resources as a way of "preserving them for future generations." Within the last few years, important finds, such as remnants of the old city's protective stockade, sloop docks, an 18th-century rum factory, old cemeteries, and Native American sites, have been reburied under public facilities.

Ironically, the city has paid a heavy price. According to the census of 2000, the population of Albany dipped below 100,000 persons (94,301) for the first time in nearly 100 years, closely resembling its population of 1890.

7

As the figures show, if you make it easy to commute and you strip a city of its historic roots and fabric, ther there is little incentive to live there.

Although many important buildings have either been altered or destroyed, a great deal of Albany's architectura history has been preserved in drawings, paintings, and photographs. Many of these early images appear in *Ther & Now: Albany*, along with contemporary ones for purposes of comparison. The book focuses on Albany' historic downtown: the oldest streets, including Broadway, State Street, and North Pearl Street, the Unior Station area, the capitol block, and the Hudson River. It can be used as a guide for a walking tour—of one historic street during lunchtime or of the entire downtown during the weekend.

The first part of the tour begins at the corner of Broadway and State Street, proceeds north and south or Broadway, up the north side of State Street, over North Pearl Street to Clinton Avenue, down Clinton to Broadway, and ends at the Union Station area. The second part of the tour begins at the corner of North Pear and State Streets, goes up (west) the north side of State Street near the capitol area, descends to the south side of State Street, continues on to South Pearl Street and back, and then goes down the south side of State Street ending at Broadway. The third part of the tour provides a look at the river from the Rensselaer side.

—Don Rittner
August 2002
drittner@aol.com

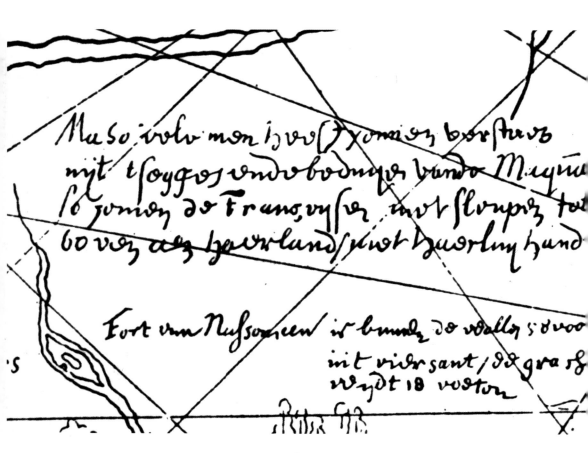

Albany had humble beginnings. Fort Nassau (page 8, the small triangle at the lower left) was built on Castle Island (now Port of Albany) in 1614. For about 100 years, fur trading remained the chief economy. This map, based on Adrian Block's surveys and logbook, gives the size of the fort: a square 58 feet wide with a moat 18 feet wide. The house was 36 feet long and 26 feet wide inside the fort. Freshets from the river forced the Dutch to move onto the mainland by 1617 and, in 1624, Fort Orange (below) was constructed slightly north of Fort Nassau's location on the right bank, or western shore, of the Hudson River.

Albany's first two farm settlements were Rensselaers Burg and Welys Burg (below). Patroon Kiliaen Van Rensselaer used these as an enticement to other shareholders and potential settlers. The two burgs represented the beginnings of the first permanent European settlement of the Capital District. Early *Huysen*

(houses) were built on *Erven* (lots) along roads that were named Joncaer Street (now State Street), Rom Street (now Maiden Lane), and Pearl Street (now North Pearl Street).

Chapter 1

IN THE BEGINNING

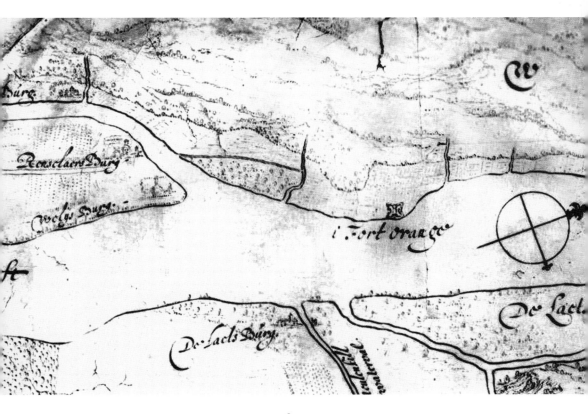

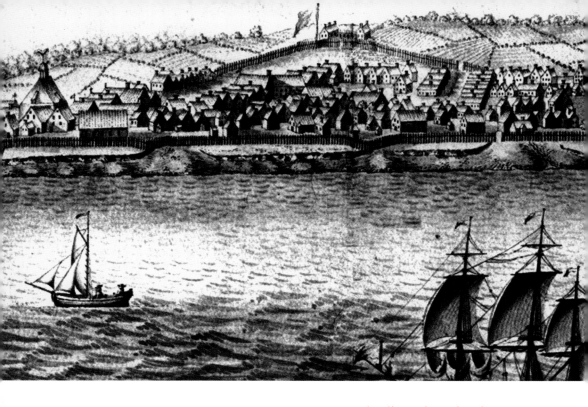

This is the earliest known view of Albany, *c.* 1692, according to historian John Wolcott. The date is estimated by several factors, including the following: St. Peter's Church (1715) is not yet built; the gate (1702) in the wall on the south side of the fort is not yet open, the ensign (1706) on two ships in the river has not been changed. It shows downtown Albany, with the log Dutch church topped with the rooster weather vane, State Street running uphill to Fort Frederick on the left, and the protective stockade without any streets southwest of it.

The earliest known image of Beverwyck (the official name given to Albany, along with a village charter, in 1652) exists in the form of a rough sketch (lower right), probably created by a committee named on November 4, 1659 to build a plank wall in response to the Esopus war, which was going on farther south.

The first concentrated permanent settlement outside the walls of Fort Orange was called the Fuyck (because it looked like a type of fishnet by the same name), or Byeenwonighe ("the dwelling together") in 1648. The 1759 British map of Albany (right) shows the protective stockade that surrounded the expanding city wall and settlement. The original structure of planks and posts was put up in 1659, and the first stockade was constructed in 1671 from cut oak and, later, pitch pine. Stockades were abandoned after the French and Indian War—post-1763. Over the years, parts of the stockades have been unearthed by archaeologists but then lost again when covered or replaced by buildings or parking lots.

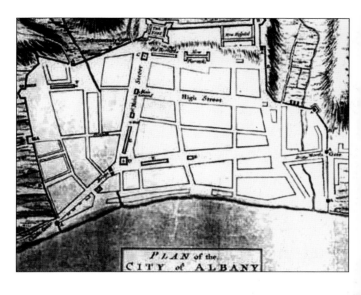

In 1968, Albany historian John Wolcott pinpointed the original Fort Orange, and partial excavations were carried out in 1970–1971. Today, a plaque on the retaining wall marks the site, and much of the fort lies under Interstate 787 and in front of the Ramada Inn. Instead of excavating the fort, however, the city is proposing to build a replica of it near the river as a tourist attraction.

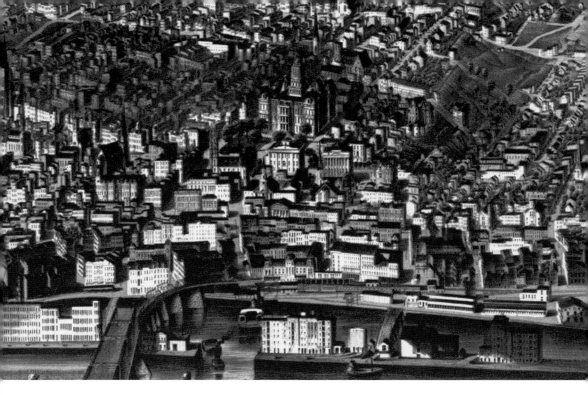

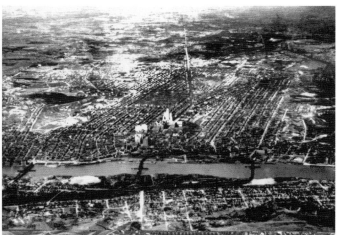

The 1879 bird's-eye view shows Albany as a major river city with its industries concentrated along the Hudson River. The Albany Basin, finished in 1825, connected to the Erie Canal and could hold up to 1,000 canal boats. Albany was the eastern terminus for the canal, to the right, and a sloop lock on the south allowed shipments to New York City and beyond. The basin is now filled and part of the interstate highway system.

The *c.* 1927 aerial view shows Albany at its peak in population and importance. The city appears as a rectangle, with the Great Western (1799) and Albany-Schenectady Turnpikes (1805) forming a Y in the center. The outlines of early stockade locations can be seen on the left in the form of Beaver, Hudson, Division, and Hamilton Streets. The Albany Basin is still visible.

The Dutch church was the center of early Albany. It was located at the junction of Broadway and State Street. The first church was built in 1656 of square timbers (block construction). In 1715, it was replaced with this stone-and-brick building, which remained until 1806. Notice the rooster weather vane. This view is looking north from the center of Broadway, with State Street to the left.

Chapter 2

ON

BROADWAY

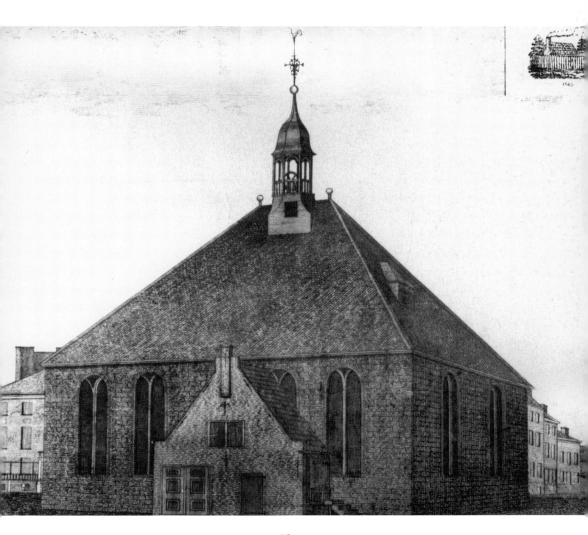

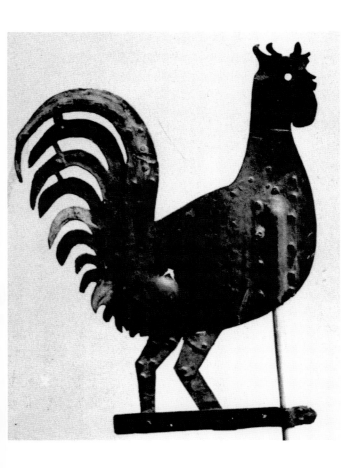

This rooster is considered to be the oldest weather vane in America. First set atop the wooden Dutch church (page 10), the rooster was transferred to the stone church (page 13) and remained there until the building was demolished in 1806. It then was taken to the South Dutch Church on Beaver Street and then, *c.* 1883, to the new Dutch church on the corner of Madison and Swan Streets. When that church burned in 1939, firemen spent days searching the ruins for the vane because of its historic significance. Today, the rooster is at the First Dutch Reformed Church on North Pearl Street, and a replica of it sits atop the church. The bullet hole is reported to have been made during a New Year's revel.

The Albany Exchange Building (below) was built on the northwest corner of State Street and Broadway in 1836. It became the National Exchange Bank in 1885 and moved to 458 Broadway. The New York Central Railroad and the post office were housed here.

The Mechanics and Farmers Bank (right) was located to the left of the Exchange Building on Court (South Broadway) and Exchange Streets. In 1891, the bank moved to State and James Streets.

Both the Exchange Building and Farmers Bank were torn down in 1875 to make way for the Government Building (below), first occupied in 1883. From 1884 to the 1930s, the Government Building served as the post office. It is seen here as part of the central office complex of the State University of New York.

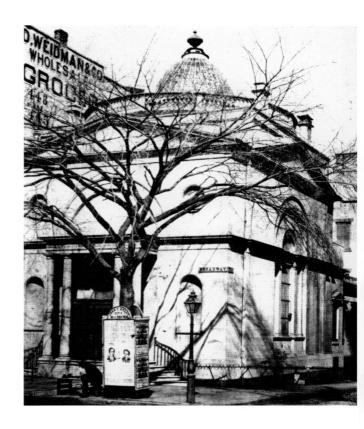

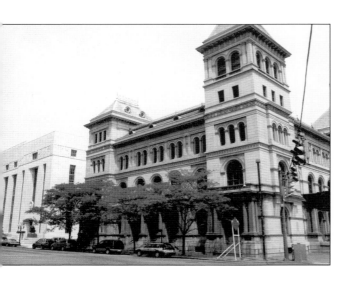

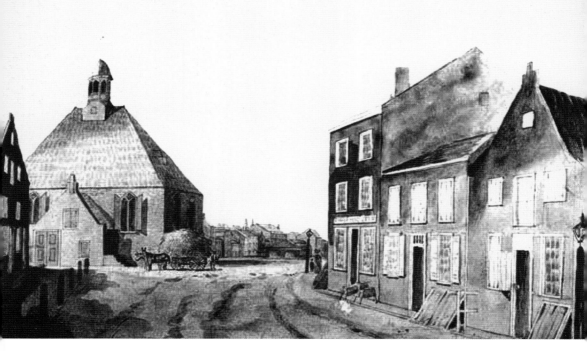

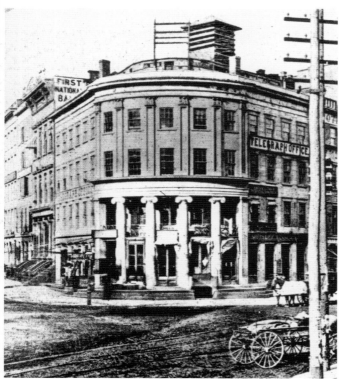

Artist James Eights created the scene looking north from Court and State Streets *c.* 1806. The Dutch church at State Street and the public market can be seen in the background. Notice the rooster weather vane (pages 10, 13, and 14).

In 1830, Albany's museum (left) was located at the northwest corner of State Street and Broadway in the Marble Column Building, later called simply the Museum Building. It was here, on March 22, 1817, that gaslight for illumination was first demonstrated.

In 1904, the Museum Building was replaced by a new structure (right) designed by Marcus Cummings. First Trust, formed in 1900, occupied the building for years.

In 1805, the west side of Broadway from State Street north to Maiden Lane (below) was the site of the Dutch church, which is just out of view to the far left. Homes or businesses, from left to right, were Myndert & John Van Schaick, Davis Waters, David Newland, Elbert Willet, Albany Bank, John Maley (Mansion House Hotel), Abraham Ten Eyck, Douw B. Slingerland, Barent G. Staats, Teunis Van Vechten, John Abraham Brinkerhoff, and Mrs. Douglas's toy shop.

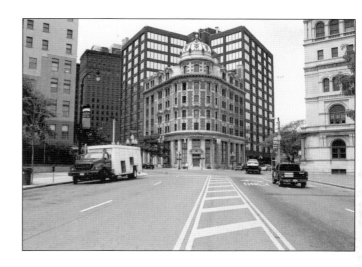

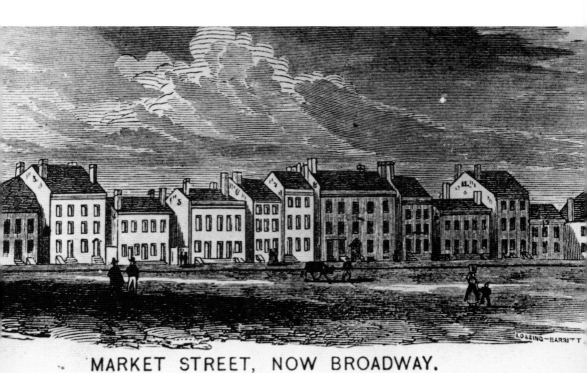

MARKET STREET, NOW BROADWAY.

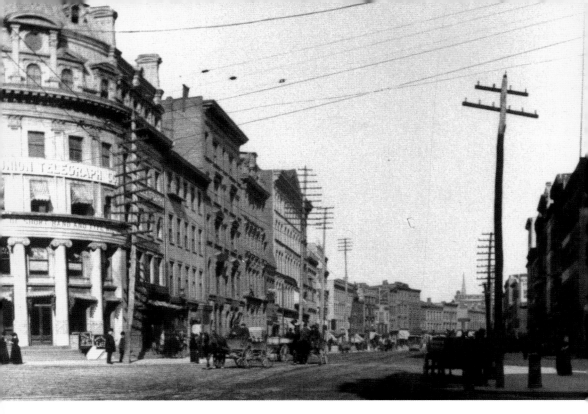

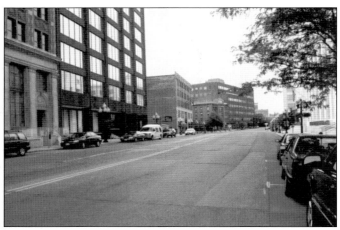

Along the west side of Broadway from State Street north to Maiden Lane *c.* 1908 were many retail stores. Today, the same area has office buildings and vacant lots.

The scene created by artist James Eights *c.* 1805 (below) shows the east side of Market Street (Broadway) looking south from Maiden Lane. The public market (hence, Market Street) is in the middle, and the Dutch church stands on the right at State Street. The house to the right of the lamppost belonged to Gen. Peter Gansevoort of Revolutionary War fame.

By 1864 (right), Dutch houses had been replaced by commercial structures. The son of General Gansevoort, the hero of Fort Stanwix, built the domed Stanwix Hall (Hotel) in 1833. The general's grandson, Guert Gansevoort, while in the navy, condemned three young sailors to death, including the son of the secretary of the navy. Because of this, Guert Gansevoort's cousin, author Herman Melville of Troy, was inspired to write *Billy Budd.* All eight of the buildings from Maiden Lane south were torn down in 1933.

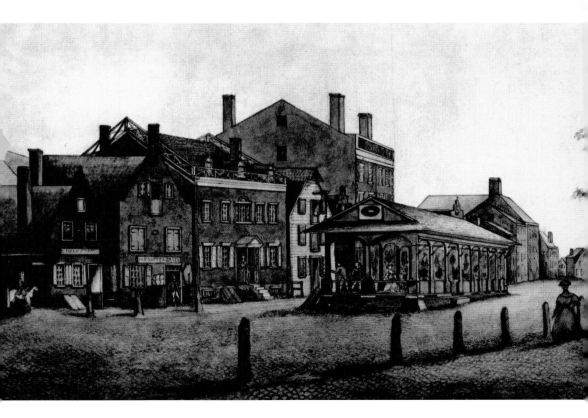

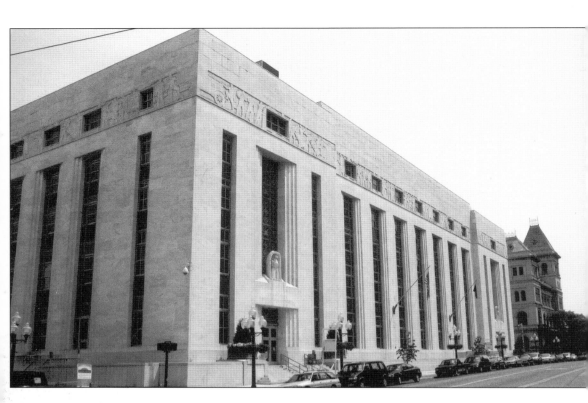

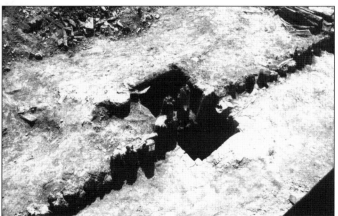

The eight buildings shown in the 1864 photograph on page 19 were replaced by a Works Progress Administration project in 1933. Notice the workers frieze along the top. The post office was located here. Today, the building continues to be used for federal purposes, although not as a post office.

In 1999, archaeologists uncovered a section of the Albany stockade behind the post office building as work began for the construction of a new parking garage. Also unearthed were parts of the Albany Basin, the wharf where the Hudson River sloop *Experiment* left for China in 1784, and a possible Mohican fishing area. The parking garage now covers all.

The 19th-century view (below) shows the block at the southeast corner of lower State Street and Broadway. These were among the buildings that were torn down in 1915 to make way for the D & H Plaza.

The other scene, looking north on Broadway from Division to Hamilton Street, shows blocks that were also demolished for the D & H Plaza.

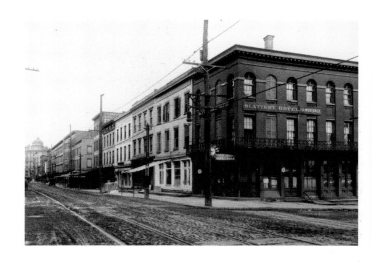

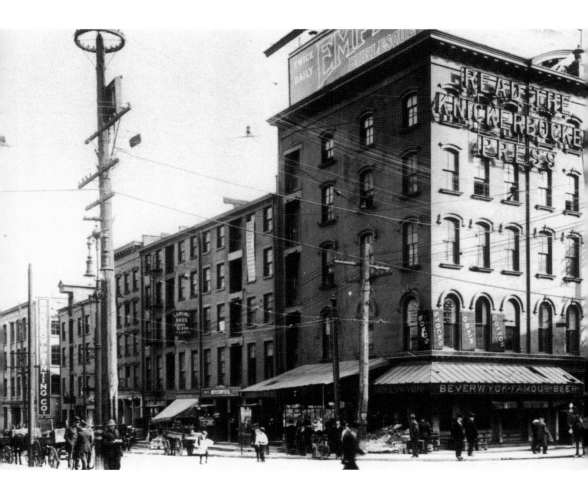

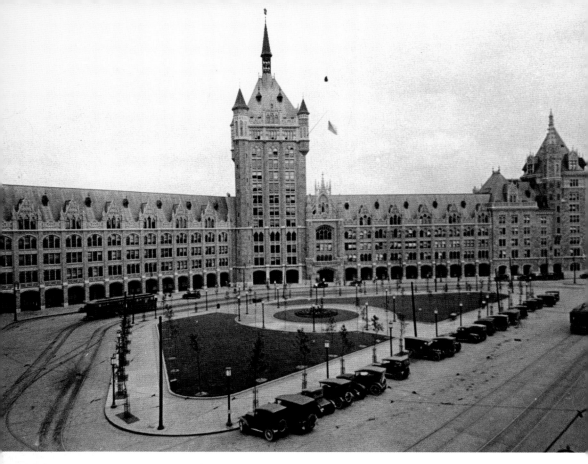

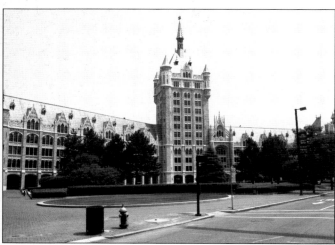

The D & H Plaza was designed by Albany architect Marcus Reynolds, based on the Flemish Gothic style of the Guild Hall of the Cloth Makers in Ypres, Belgium. For years, this was the place to catch the trolley—and, later, the bus.

The central offices of the State University of New York now occupy the plaza, no longer a public space.

Albany's first city hall, the Stadt Huys, was located at this site and here, in 1754, Benjamin Franklin proposed the Plan of Union, which marked the beginning of the move to unite the states. Peter Schuyler, Albany's first mayor, lived here and most versions of the defensive city walls passed through here. Because of the site's historical importance, the author and his friend John Wolcott suggested that the plaza be excavated and turned into an archaeological park, with Albany's original name, Beverwyck.

State Street is one of Albany's oldest and most majestic streets. Shown in 1837, the street was always broad and, today, is still the city's main thoroughfare. It has undergone massive changes in architectural style, as seen in the following set of images. The stagecoach used to stop at the Museum Building, as seen here. The original capitol building can be seen at the top of State Street, where it still stands. Gas for illumination was first demonstrated here at the Museum Building in 1817; however, gas was not used for street lighting until 1845.

UP STATE STREET

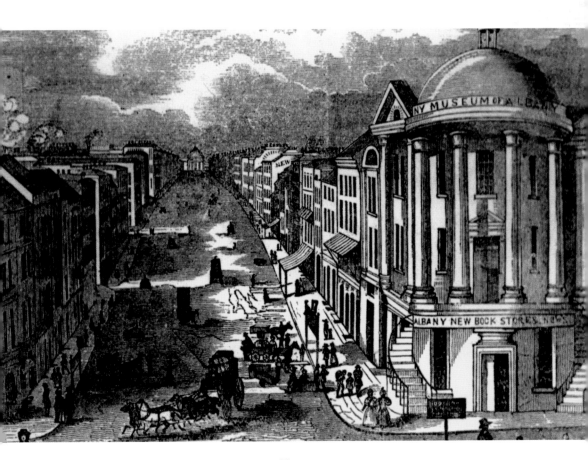

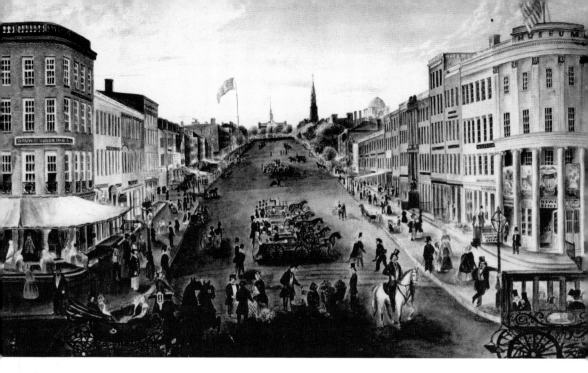

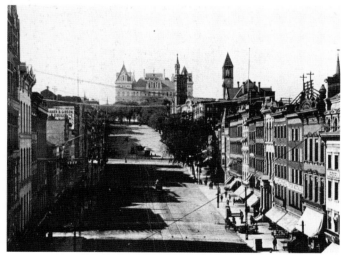

State Street was a busy road in 1845 (above). Notice the man leaning on the gas lamp. This view may explain wh State Street was so broad: even with the horse-drawn buggies lined up, there is st room to travel.

In the 1890s, the new capitol towerec at the top of State Street. Also visible are the present city hall and some electric trolleys. Trolleys began going up State Street as horse-drawn trolleys in 1864.

By 1928, buses had become a common
carrier along State Street and; by
1946, they had replaced trolleys.
Today, lower State Street no longer
exists. Commercial skyscrapers fill much
of the skyline. The capitol and the Alfred
Smith Building, erected in 1929, can be
seen at top of the street (below). A row of
19th-century buildings still exists on the
west side of Broadway.

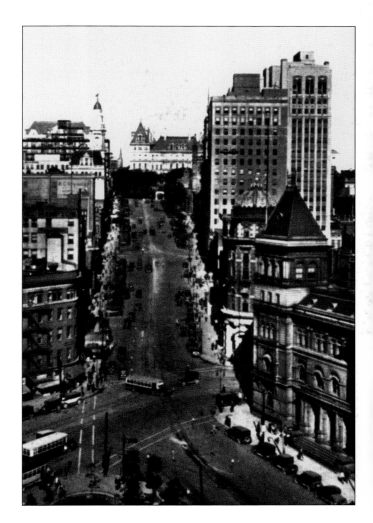

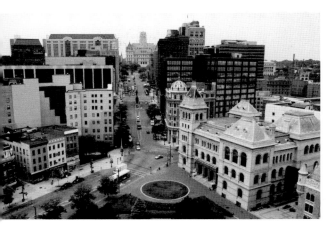

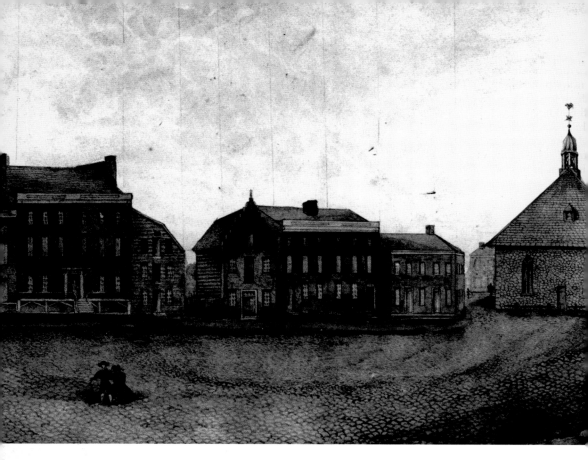

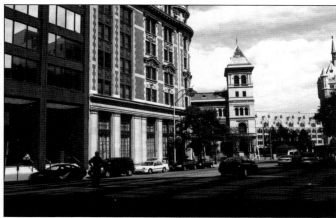

The *c.* 1806 State Street scene looking east from James Street was done by artist James Eights. The Dutch church is on the right.

The other view shows the same area in 2002.

Except for the Farmer's Bank (the turreted building), all of the 19th-century buildings (below) on the north side of lower State Street are gone. The tall building is the Ten Eyck Hotel, which was razed in the 1970s.

In the contemporary view, find the Farmer's Bank and compare its appearance with that in the early-20th-century view.

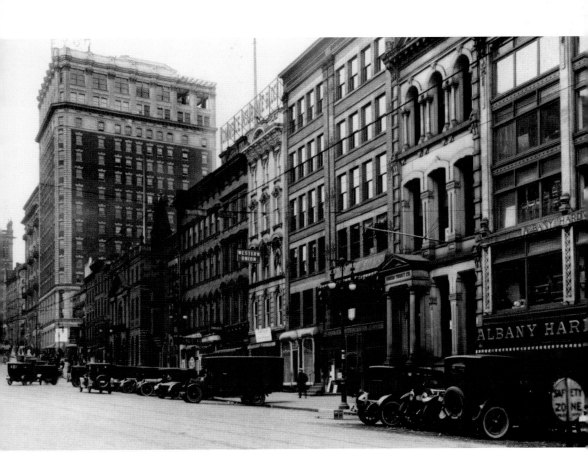

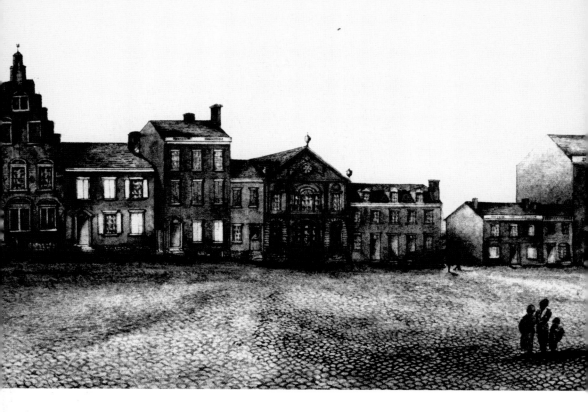

The *c.* 1806 view of lower State Street at James Street was created by artist James Eights. The State Bank building appears in the center of the image. The Dutch house at the far left on the northeast corner of State and North Pearl Streets was known as the Balthazar Lydius House and survived until 1833.

State Bank was incorporated in 1803. Its first president was former New York governor John Tayler. Architect Philip Hooker designed the building .

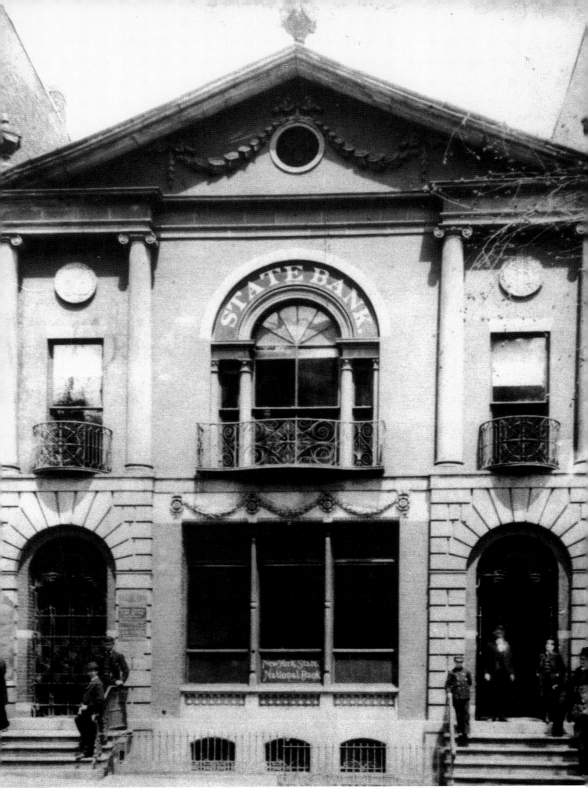

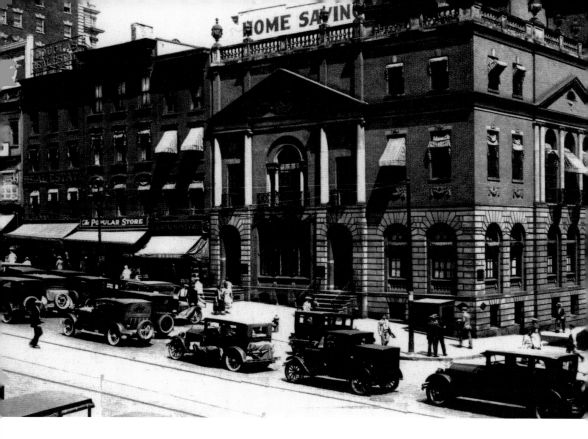

When State Bank expanded, the addition was built at the right on James Street and another floor was added. The facade of the earlier bank was saved and mimicked on the James Street side. This photograph dates from *c.* 1914.

The Dearstyne Building (below)
occupied the northeast corner of
[Sta]te and North Pearl Streets. The view
[com]es from c. 1914, many years after the
[Bal]thazar Lydius House was
[tor]n down.
[I]n 1937, the Dearstyne Building and
[adj]acent State Street structures were torn
[do]wn and the facade of the original State
[Ba]nk was incorporated into the center
[of] a new State Bank skyscraper (right),
[cu]rrently used by Fleet Bank.

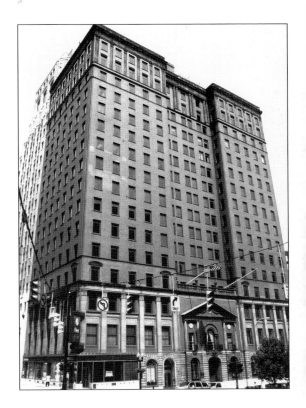

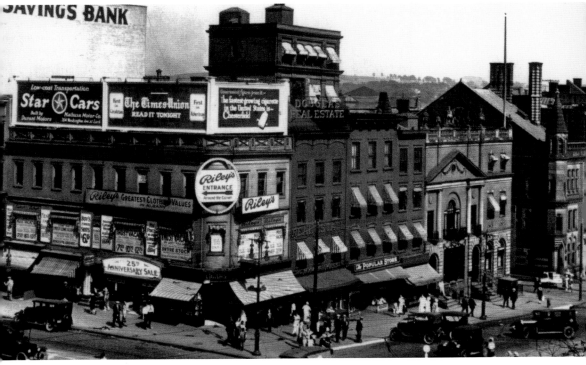

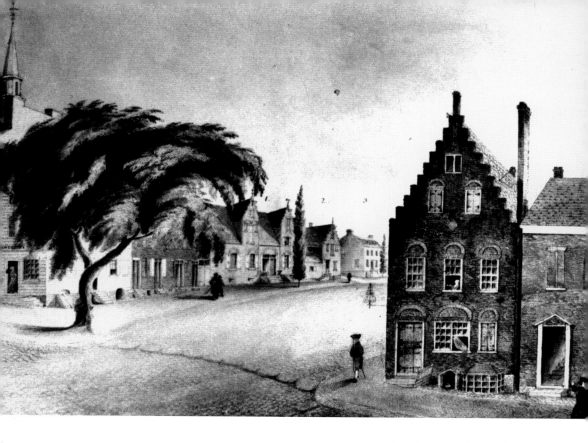

Elm Corner is the northwest corner of State and North Pearl Streets. The site originally was the home of Philip Livingston, one of the signers of the Declaration of Independence. Livingston planted the elm tree on the left, and it lived for 123 years. The Balthazar Lydius House is on the right.

Philip Livingston's elm tree still lives at the corner in the mid–19th century. The corner block (below) included a pianoforte factory and, later, Webster & Skinner's Bookstore, where for 50 years the *Gazette* and *Daily Advertiser* were published.

Tweddle Hall (right), a concert hall, replaced the pianoforte building in 1860. The hall burned in 1883. Before the fire, on June 15, 1877, the old elm was cut down. The photograph is from *c.* 1870.

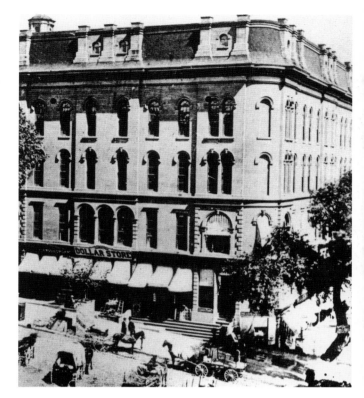

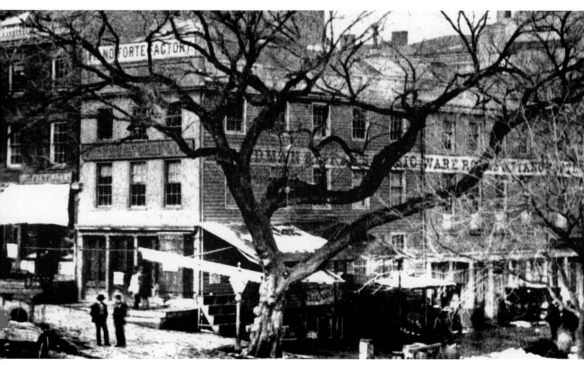

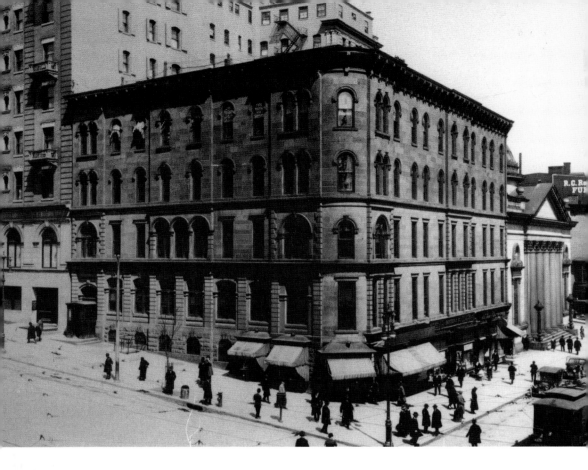

On the northeast corner of State and North Pearl Streets, a new Tweddle Hall was raised from the ashes by lawyer John Tweddle. Pictured *c.* the 1890s, the hall survived until 1915.

In 1915, Tweddle Hall was razed for an expanded 15-story Ten Eyck Hotel, shown *c.* the 1920s. F.W. Rockwell built the original Ten Eyck just west of Tweddle Hall in 1899.

In the 1970s, the Ten Eyck was razed to make way for a modern building which has housed a number of tenants, most of them banks.

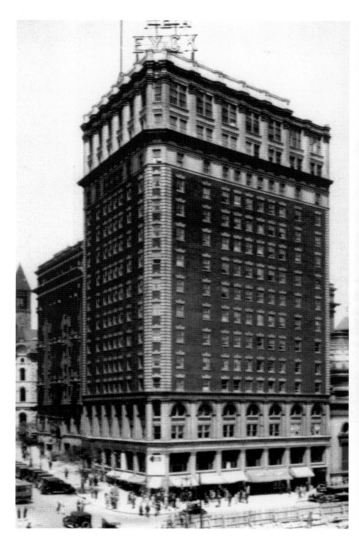

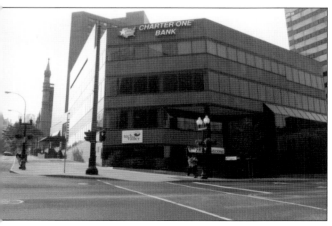

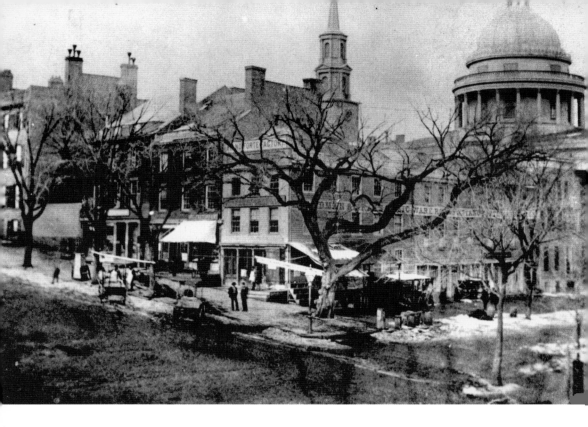

Three views of the northeast corner of State and North Pearl Streets show a striking contrast in architectural form and function—an excellent example of the change in style that took place in many cities during the latter half of the 20th century.

Shown are views from the 1860s (above), 1903 (lower right), and the present (upper right), covering a span of nearly 150 years. Note that the present hotel has no windows on the State Street side and that those of the bank are dark and not at pedestrian level.

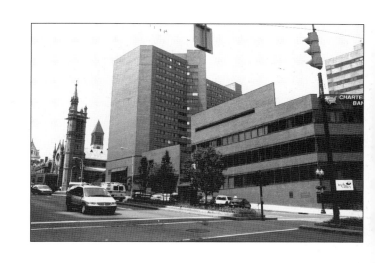

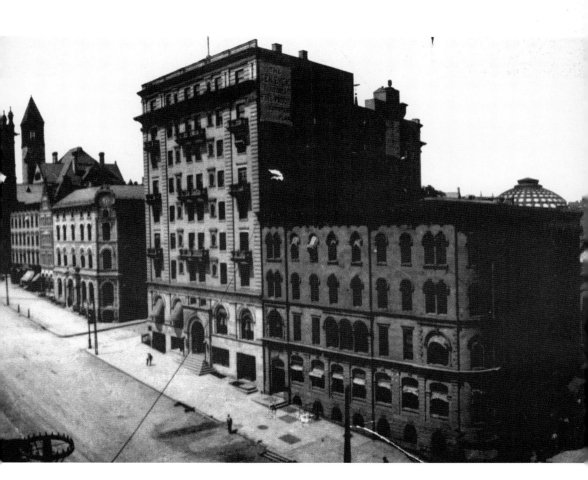

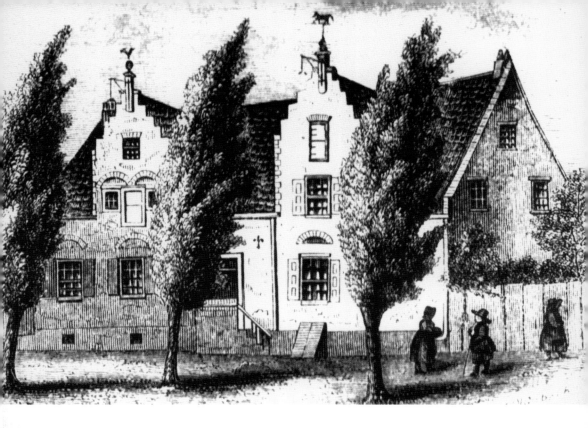

The Vanderheyden Palace stood next to Philip Livingston's house, on the southwest corner of Maiden Lane and North Pearl Street. Built in 1725, by Johannes Beekman, it was purchased in 1778 by one of the Vanderheydens of Troy. It figured in Washington Irving's "Bracebridge Hall," the story of Dolph Heyliger, as the residence of Heer Anthony Vanderheyden.

Irving took the iron weather vane, in the form of a horse at full speed, when he transformed his old farmhouse into "Sunnyside." Even his southern gable is an exact reproduction of the Albany palace. Sunnyside is now a historic site, and the weather vane is being preserved.

The Second Baptist Church (right) replaced the Vanderheyden Palace and occupied the site until 1870.

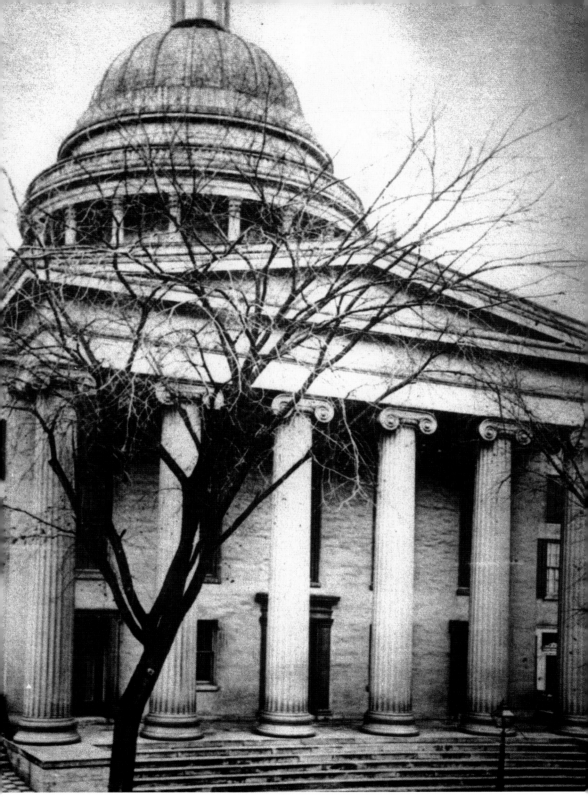

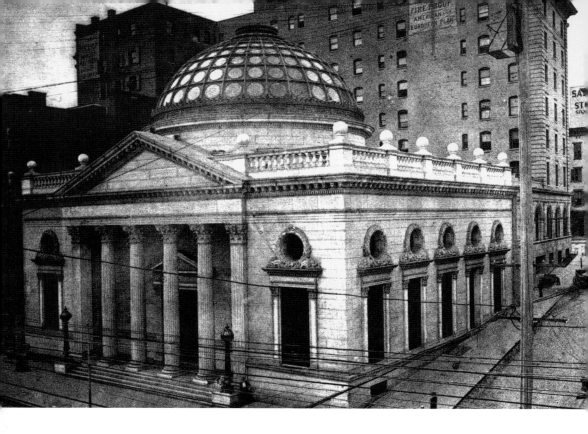

The Second Baptist Church was
replaced by this elegant classical
structure erected for the Albany Savings
Bank, which was chartered in 1820. The
photograph dates from 1907.

In the 1970s, the Albany Savings Bank was torn down, with the blessing of city hall, shown in the background of a telling photograph (below) captured by historian John Wolcott.

The ornate bank was replaced by a bus stop (right), and Maiden Lane disappeared as well.

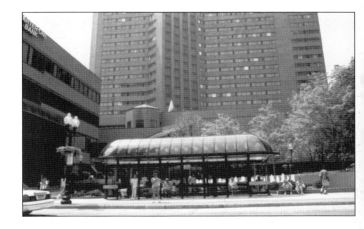

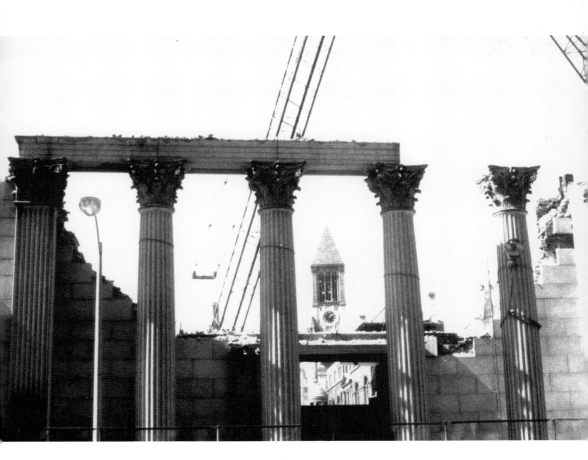

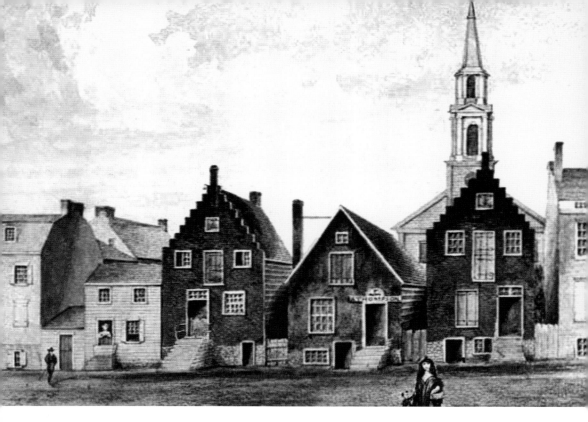

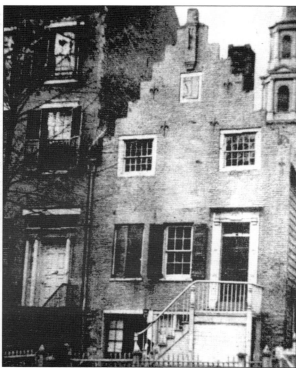

The 1806 view looking north on Maiden Lane to Steuben Street was done by artist James Eights in 1806. North Pearl Street consisted of several Dutch period houses. From left to right are the home and office of the dentist Dr Woodruff; the houses of William Eights, Bob Thompson, and Widow Sturdevant; a house in front of the church; and the home of Dr. C.C. Yates. Not shown is Uranian Hall and two buildings that were torn down to make way for the Female Academy.

The Widow Sturdevant house is still standing in the 1860s (left).

The Female Academy (right) was built in 1834. Ebenezer Foot founded the first building on Montgomery Street in 1814 as the Union School. In the 1890s, the school moved to Washington Avenue near the present Albany Public Library. Today, it is the Girls' Academy on Academy Road.

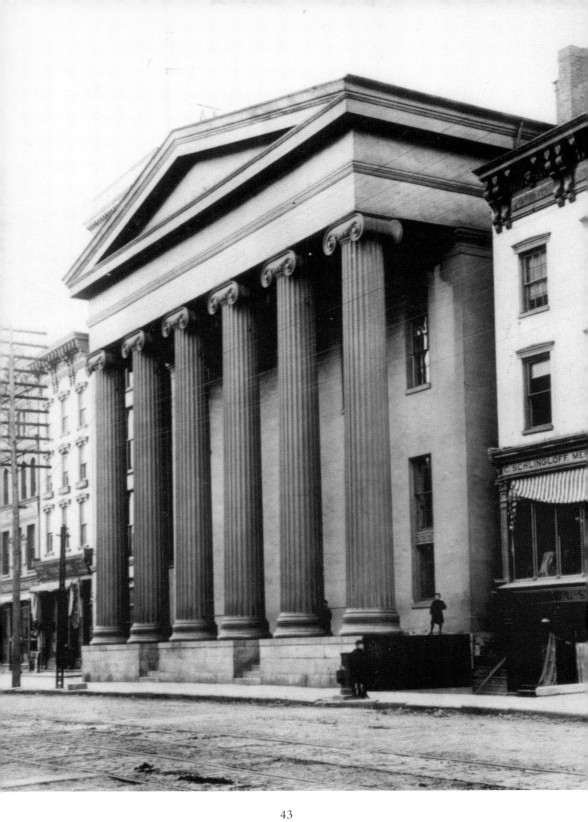

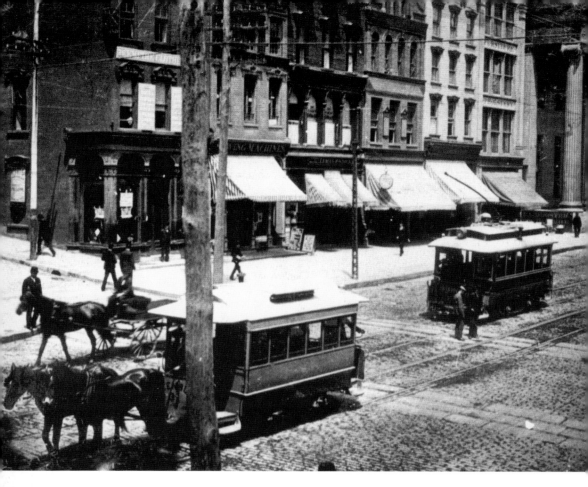

North Pearl Street *c.* the 1880s is busy with horse-drawn and electric trolleys. Shown is the area from Maiden Lane north to Steuben Street. Maiden Lane, the columned Female Academy at the far right, and all of these buildings are now gone.

A large brick office building, with rows of dark glass, has replaced old Dutch homes, the Female Academy, and the 19th-century commercial buildings that once stood here.

The artistic scene looking southward along North Pearl Street between Steuben and Columbia Streets was depicted by James Eights in 1812.

That block was transformed in the 19th century, particularly by the end buildings—the YMCA building in 1886 and the Kenmore Hotel in 1878. Adam Blake, owner of the popular Congress Hotel, built the Kenmore. The Kenmore was the hangout of the infamous gangster Legs Diamond in the 1920s and was the scene of many big band–era concerts. All of these buildings have been renovated in recent times and are still in use.

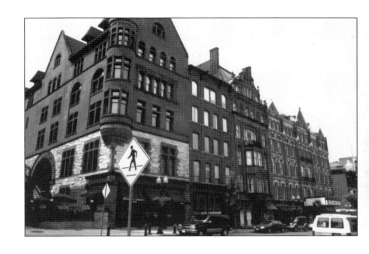

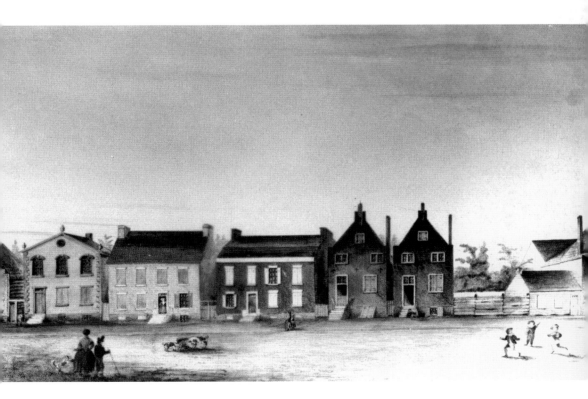

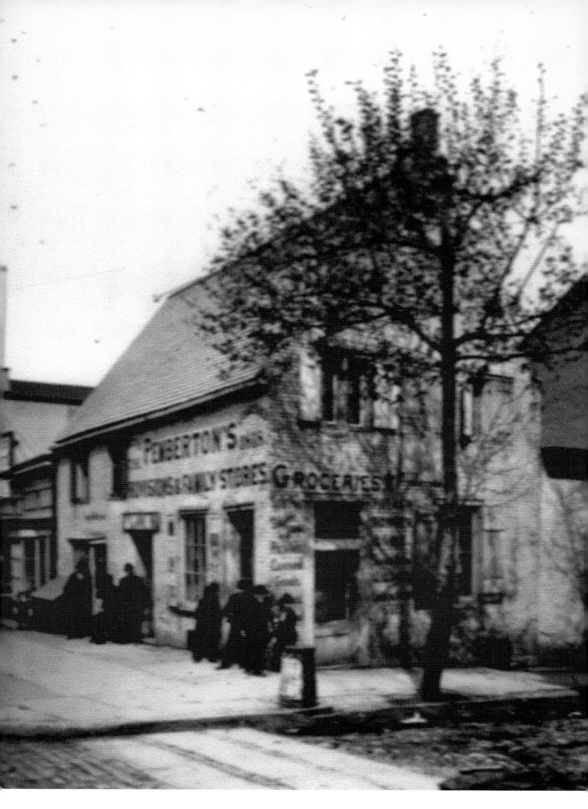

The Pemberton-Lansing House is reported to have been built in 1710 by Col. Jacob Lansing, a Revolutionary War officer. It was located on the northeast corner of North Pearl and Columbia Streets, outside the stockade, and was used as lodging when Native Americans came to trade. Known as Widow Visscher's house and, after 1818, as Eben Pemberton's store, the building was torn down during the city's bicentennial celebration of 1886. The photograph dates from *c.* 1880.

In 1887, the Albany Business College began in a large brick building (below) next to Pemberton's, on the far right. The steeple of the Dutch Reformed church is visible on the left. Notice the numerous commercial buildings.

After Pemberton's was torn down in 1886, the present building (upper right) was erected in its place and was used as

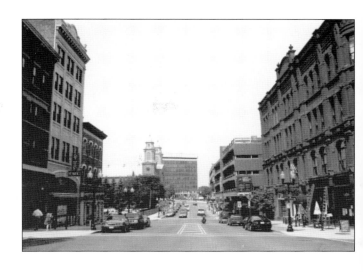

the Albany Business College until 1933. Note that all of the 19th-century commercial buildings have been replaced by a parking facility.

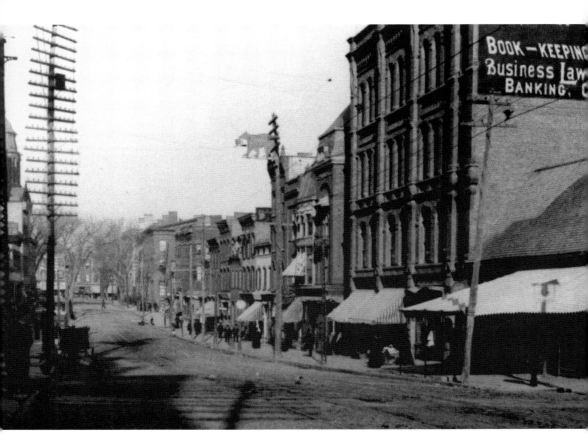

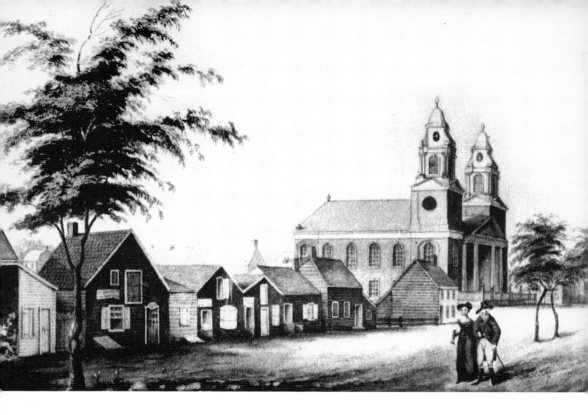

Small homes line the west side of Pearl Street north of Columbia Street in an 1806 painting by James Eights. The Dutch Reformed church is at the corner of Van Schaick Street. Albany's oldest building today, the church was designed by Philip Hooker and erected in 1798. The church has a replica of the historic rooster on its roof and the original in its possession.

By the 1890s (below, left), larger residences and commercial buildings have replaced the small homes along the west side of North Pearl Street.

Today (below, right), all of the buildings except for the church have been replaced by a parking lot.

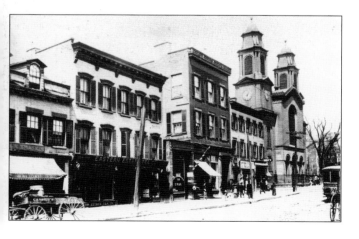

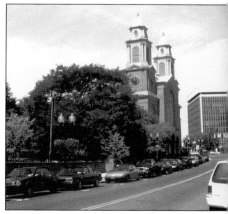

In its heyday, Clinton Square was a busy place, with homes, businesses, and a Proctor's theater. The square is located north of the Dutch Reformed church at the Clinton Avenue intersection.

Clinton Square today contains three buildings that have survived from the early 20th century. One of those is the home of Gansevoort Melville, the brother of author Herman Melville of Troy.

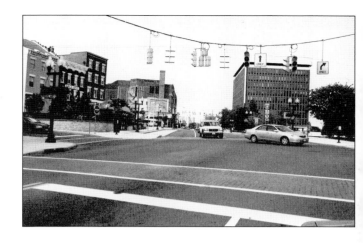

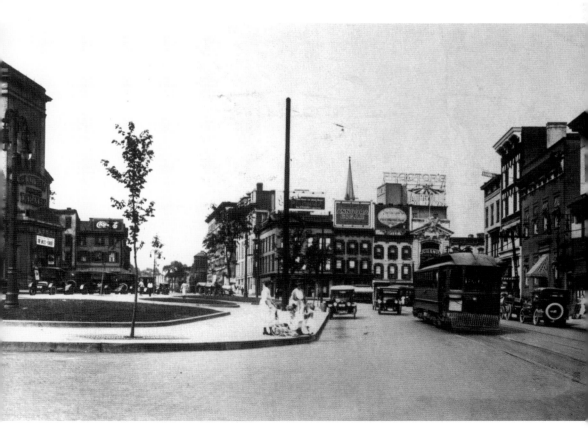

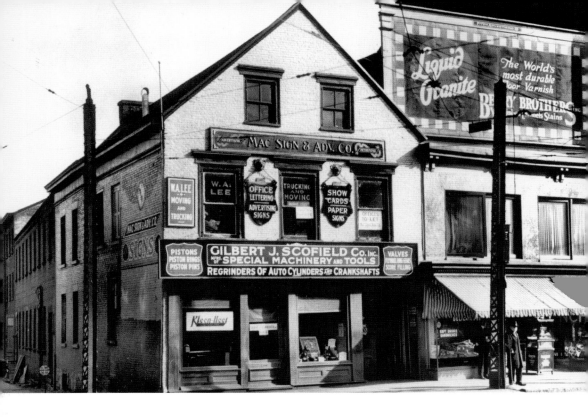

The Quackenbush House, at Broadway and Quackenbush Street just north of Clinton Avenue, was originally a Dutch dwelling of unknown date. Modified during the Federal period, it is shown *c.* the 1920s.

During the 1970s, the house was saved from demolition while most buildings surrounding it were destroyed. It is now a restaurant (below, left) with an Interstate 787 exit ramp on its south side.

In 2001, archaeologists uncovered an 18th-century rum distillery (below, right) just south and behind the Quackenbush House. It is the only one of its kind found intact in America. However, it was destroyed in the process of building a new parking garage. Two disappointed bankers paid to save two of the rum barrels for preservation.

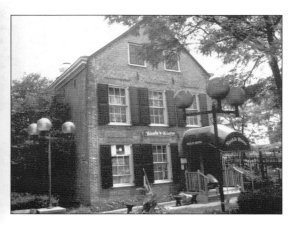

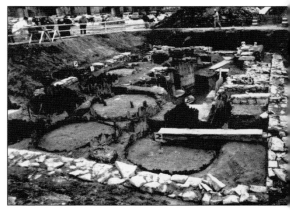

The Delavan House was a temperance hotel built by E.E. Delavan at the northeast corner of Broadway and Steuben Streets in 1844. Later, the establishment became a popular hotel for politicians. It burned on December 30, 1894, killing 16 people—two guests and 14 servants who were unable to get out of the only exit door on the top floor because it was padlocked.

Chapter 4

THE UNION STATION AREA

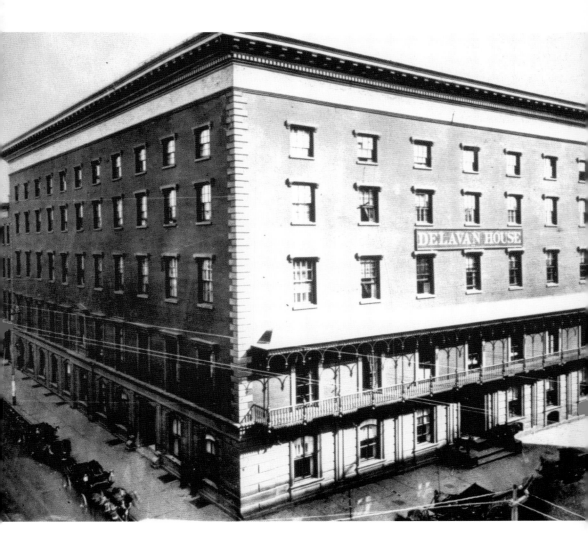

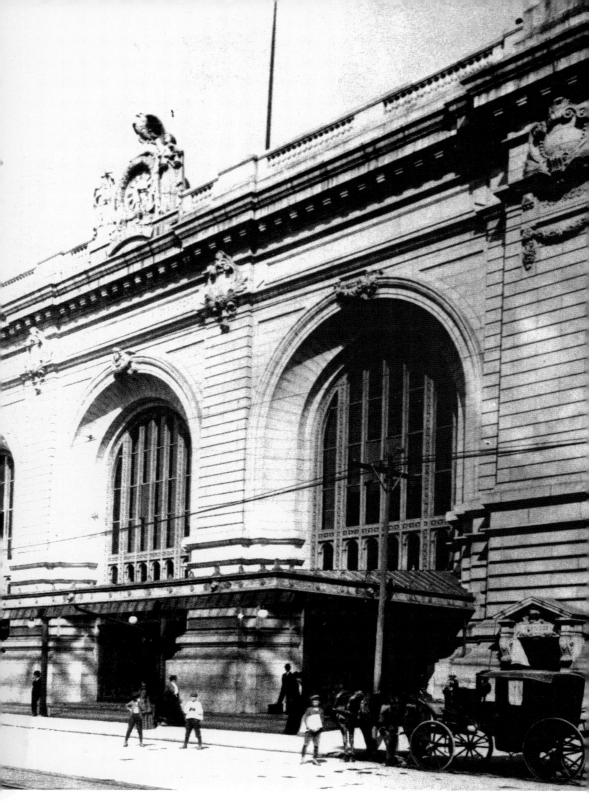

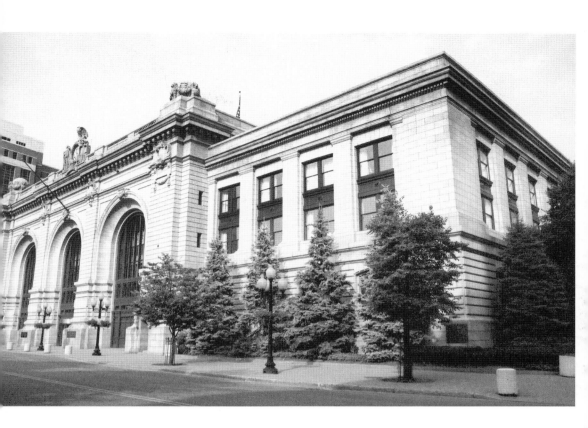

In 1900, the Delavan House was replaced by the new Union Station (left), used by the New York Central and Hudson River Railroads. An earlier station built in 1872 was located along Montgomery Street between Maiden Lane and Steuben Street.

Slated for demolition during the 1970s, Union Station was eventually saved and faithfully restored by Norstar Bank (now Fleet), which uses it as its headquarters.

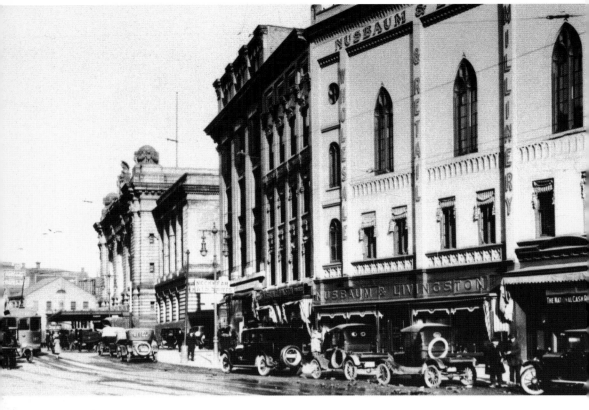

Unfortunately, the area around Union Station did not fare as well. The c. 1925 view shows the Nussbaum & Livingston building, at 525 Broadway between Maiden Lane and Steuben Street. Formerly the Temple of Music, it was the meeting room for the Burgess Corps, the city militia armory, in 1859 and the publishing house of W.C. Little & Company in 1863. Originally called Bleeker Hall, it was one of the first examples of Gothic Revival–style commercial buildings in the country.

Bleeker Hall was replaced by the controversial New York State Dormitory Authority office building. Lawsuits over archaeological sites found here forced the state to abide by its own preservation laws. Notice that Union Station is no longer the imposing figure of yesteryear; it is now dwarfed by two state office buildings, including the domed Environmental Conservation Building.

The Union Station area was busy when the station served as the central hub of transportation for the Capital District. Restaurants, commercial retail establishments, and hotels served commuters and visitors alike.

No longer the transportation hub it once was, Union Station today lacks the hustle and bustle, as all of the retail establishments have been replaced by offices.

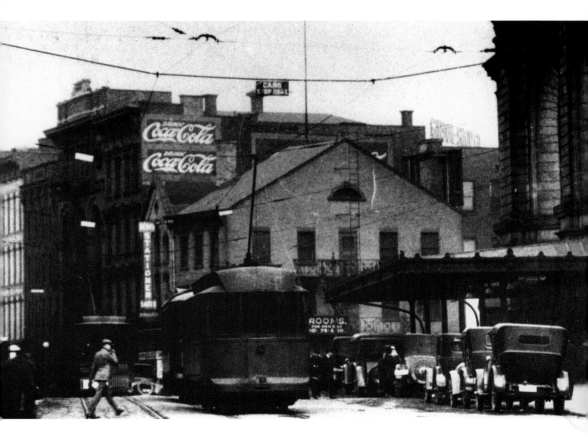

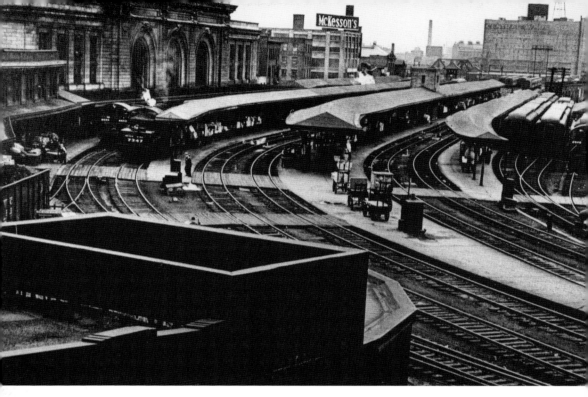

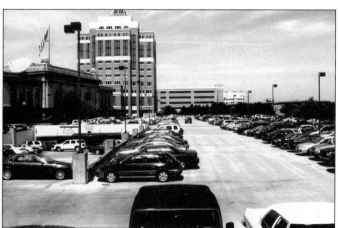

Each weekday more than 30 trains operated by the New York Central and the Delaware & Hudson Railroads traveled between Albany and Troy, only 25 minutes apart. The scene behind Union Station shows what was once the transportation hub of the Capital District.

Today, a multilevel parking garage has replaced the entire track system and the massive Interstate 787 highway system looms to the right. Union Station is now simply a symbol of an earlier time.

ort Frederick overlooks the city, with
guns pointing to the river and to
e west. Built in 1676 and later rebuilt
stone, the fort was located at the top
ate Street just past Lodge Street. It
s demolished in 1784, and parts of it
e believed to be in the foundations of
isting buildings in the city.

Chapter 5

CAPITOL HILL

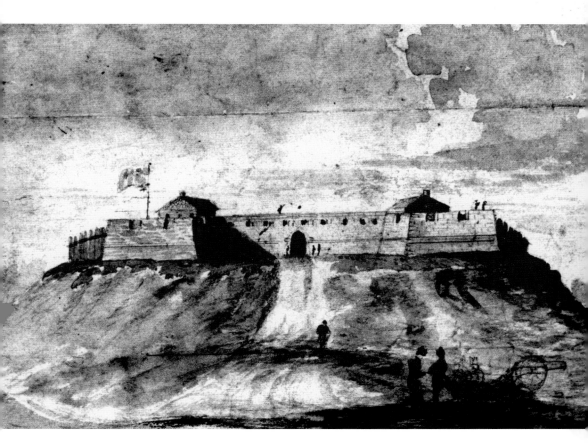

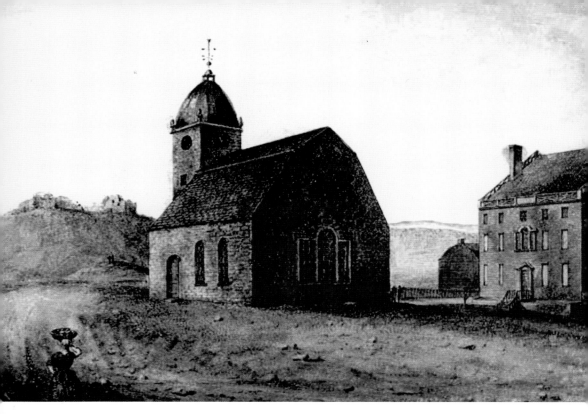

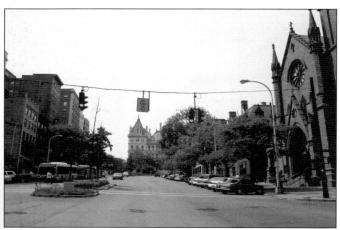

The painting shows St. Peter's Church built in 1715, facing an abandoned Fort Frederick on the west. The area around the fort (and present capitol) was called Pinxster Hill and was the scene of Pinxster Festival, an annual celebration held in May by the city's African American population.

The present St. Peter's Church faces State Street. This part of Albany has undergone a tremendous change over the last 200 years.

The *c.* 1890 photograph shows the northeast corner of State and Eagle Streets. The building with a tower on the back is located in front of city hall. Out of view to the right is the office and apartment of future president Martin Van Buren. The building on the far right was the first office of the Mohawk & Hudson Railroad (1831). In 1884, it was converted to the New York State Normal School, which later became part of the State University of New York system. The building was torn down in 1966.

Today, an island of trees obscures the view. The tower is gone, and dormer windows have been added. The building on the right was built *c.* 1967.

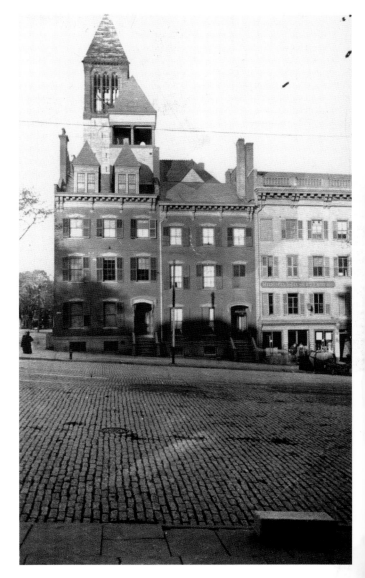

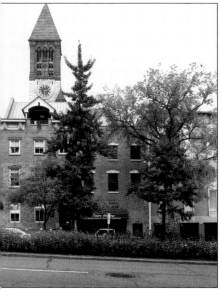

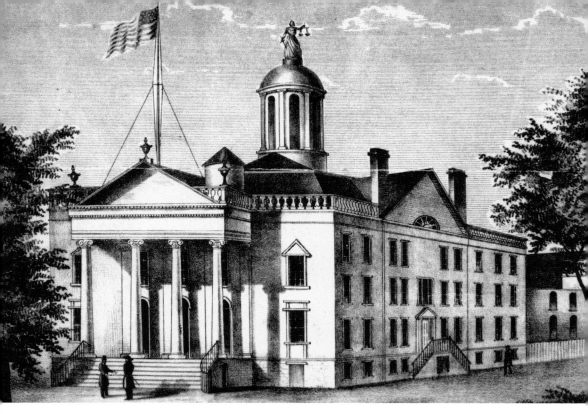

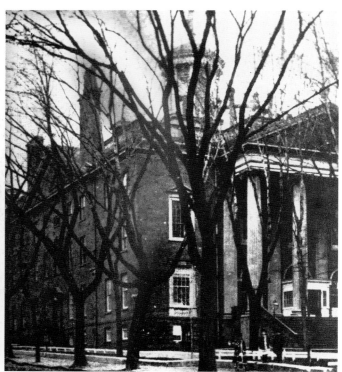

The capitol building (above, left, and upper right) stood at the top of State and Eagle Streets from 1806 to 1883. Albany became the state capital in 1797, although the legislature forgot to pass a law stating so until recently. This building was located just southeast of the present capitol.

Congress Hall (below) was built on the southwest corner of Washington Avenue and Park Street just north of the old capitol in 1815. The Marquis de Lafayette entertained here in 1824, and Mrs. Abraham Lincoln had a reception here in 1861.

The building was closed in 1865 and was demolished in 1878 to make room for a new capitol building. Adam Blake built his Kenmore Hotel on North Pearl Street right after the demolition of Congress Hall.

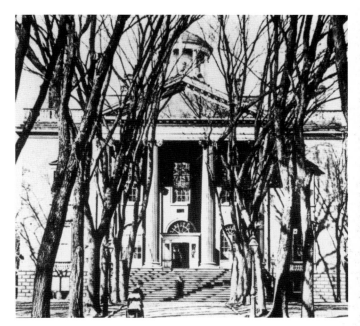

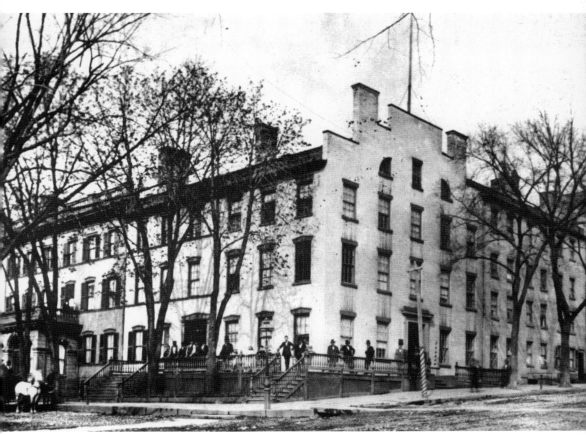

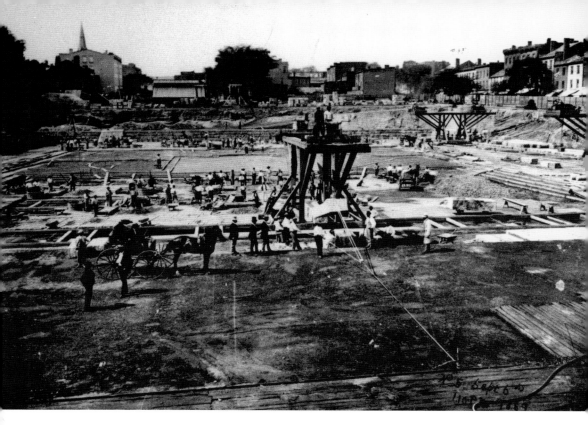

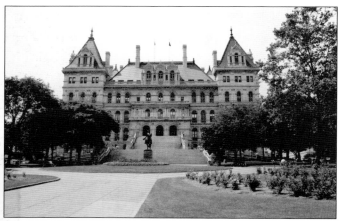

The construction of the new capitol began in 1867. In the 1869 view, the area once full of buildings has been cleared and prepared. Washington Avenue is on the right. The capitol opened in 1879 although it was not officially completed until 1881–1883. The building burned in 1911 but was quickly restored.

Today, the capitol is undergoing extensive renovations. The interior architecture is remarkable.

any buildings to the west of the new capitol were razed for a park, seen in the *c.* 1920 photograph. All of the structures shown except for the Fort Frederick apartment building on the far right were demolished. Fort Frederick was lifted and moved to a site off to the left on State Street, where it still stands. In 1929, New York erected the Alfred E. Smith State Office Building, visible behind a tree-lined Capitol Park.

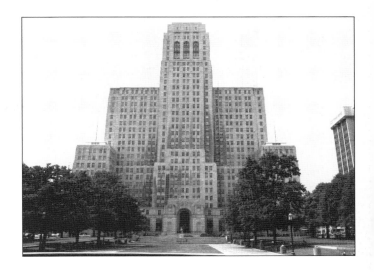

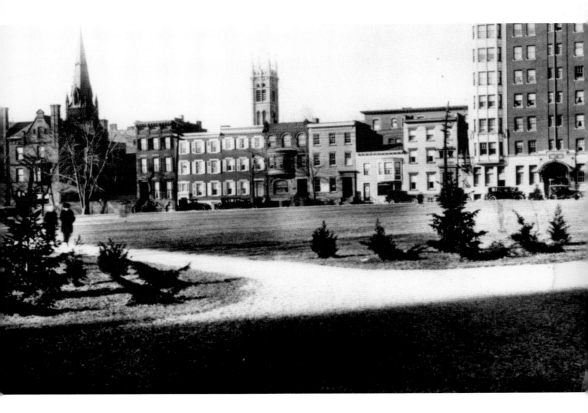

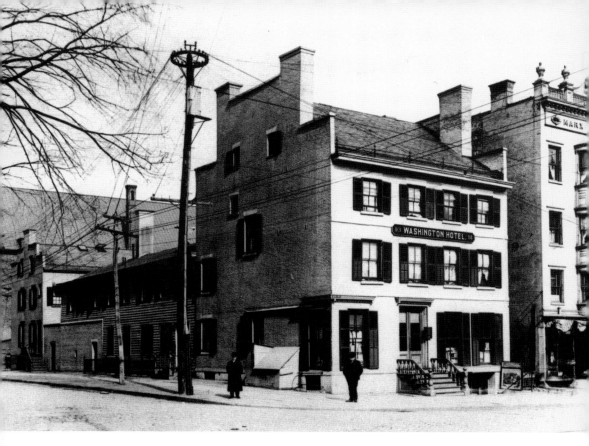

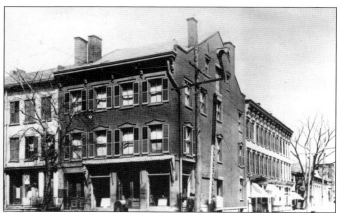

New York State wanted more space. An entire block (above), beginning with the Washington Hotel at the northeast corner of Swan Street and the neighboring Marx Building, was demolished *c.* 1900. All Saints Cathedral can be seen in the background.

Buildings on the other corner of Washington and North Hawk Streets (left) were also removed by the state.

The site for the construction of a new state building was cleared and prepared.

Erected on the site in 1912 was the State Education Building, one of New York's most beautiful classical buildings. It was once the home of the New York State Museum, the oldest continually operating museum in the country. Specimens from the old Geological Hall on State Street and from the statehouse on Eagle Street were moved here. The museum is now located in the Empire State Plaza, but this building is still used today for state offices.

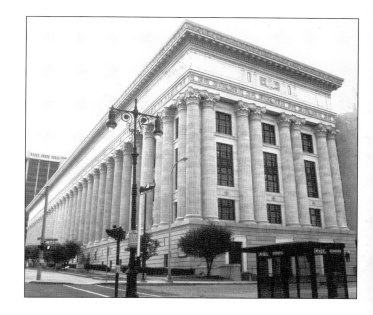

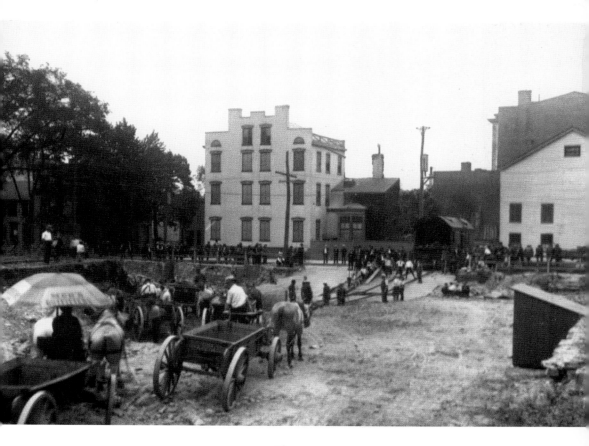

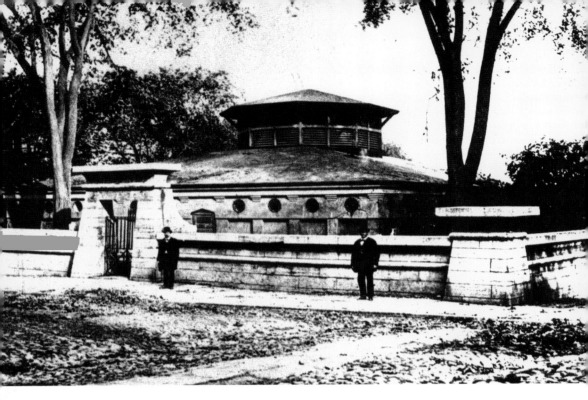

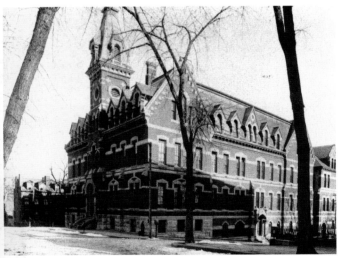

The Albany Water Reservoir was located just east of the State Education Building on Eagle Street between Steuben and Columbia Streets. Shown in 1861, it is one of the few examples of Egyptian Revival architectu in Albany. Originally, a British army hospital that trained local women as nurses was located here during the Frenc and Indian War.

In 1876, the reservoir was taken out and replaced with the Albany High School.

The high school was demolished in 1916 to make way for the Albany County Courthouse (right), which still occupies the site.

The new State Hall (below) was designed by Henry Rector and built in 1842 to the right of the courthouse. It replaced the old hall, located on Lodge and State Streets. It housed the offices of the chancellor, supreme court judges, secretary of state, and others. Today, it serves as the State Court of Appeals.

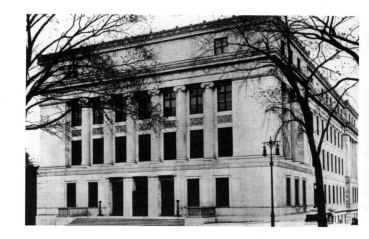

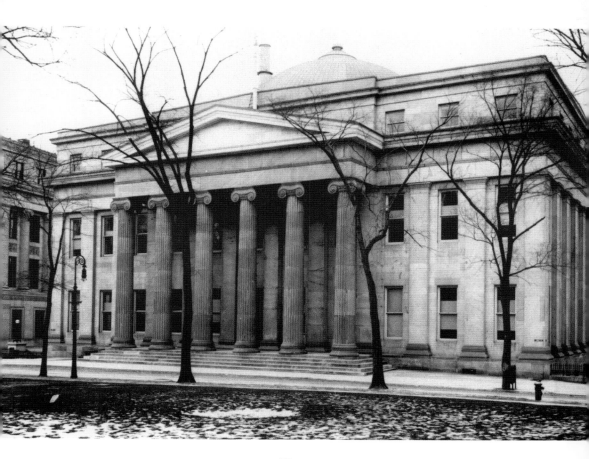

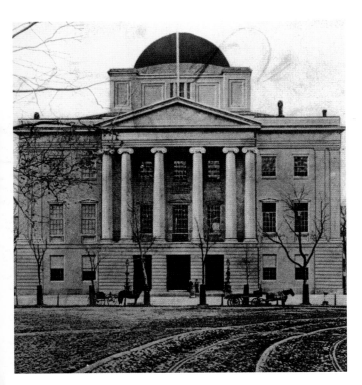

The third Albany City Hall was built in 1831–1832 on Eagle Street just south of the State Court of Appeals building on the other side of Maiden Lane, between it and Pine Street. The building burned on February 10, 1880.

The present city hall was designed by Boston architect H.H. Richardson and was built on the site of the previous one in 1881–1883.

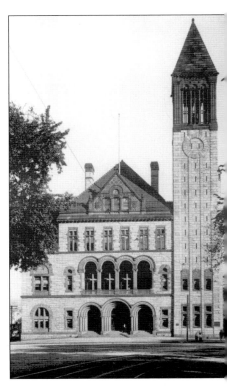

Artist James Eights created this view looking west toward the Hudson River from the Fort Frederick area in 1806. The Dutch church is at the bottom of State Street. James McChesney's Chair Factory is to the right. McChesney always sawed his wood out front.

Chapter 6

DOWN STATE STREET

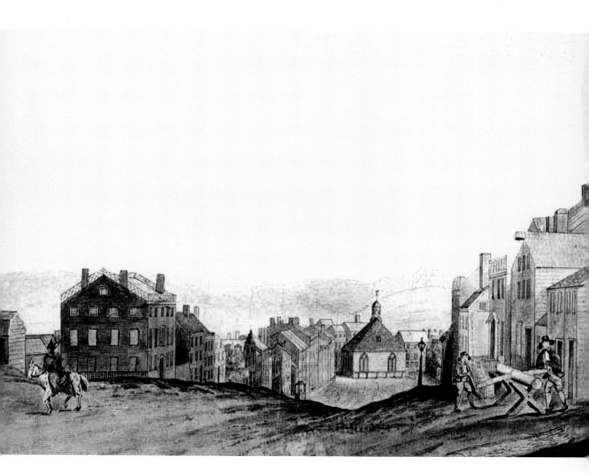

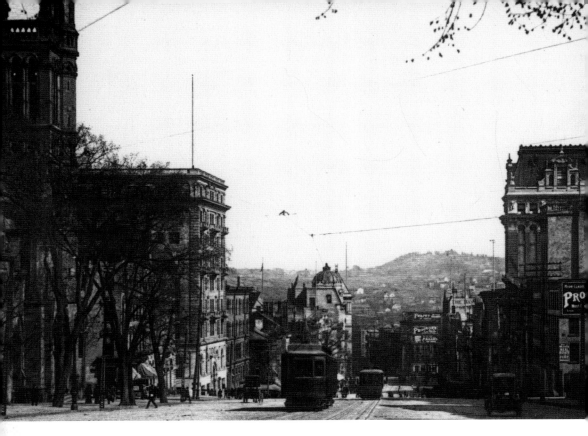

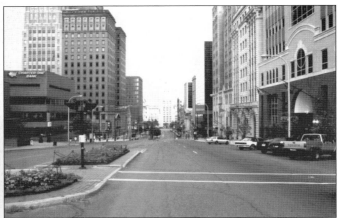

These two view were taken looking west toward the Hudson River from the Fort Frederick area. The large hill in the background of the 1910 photograph in the city of Rensselaer.

The D & H Plaza is the centerpiece of today's view.

During the 19th century, the southeast corner of State and Eagle Streets was the site of stately homes. Many of these mansions, viewed here from the Capitol area, were razed or remodeled for commercial uses.

Today, the old Dewitt Clinton Hotel is on the corner and the buildings to its right stand vacant and in danger of being demolished.

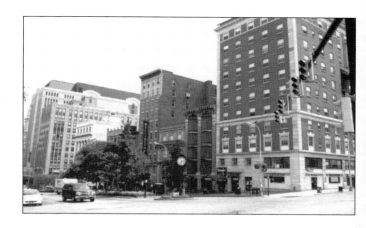

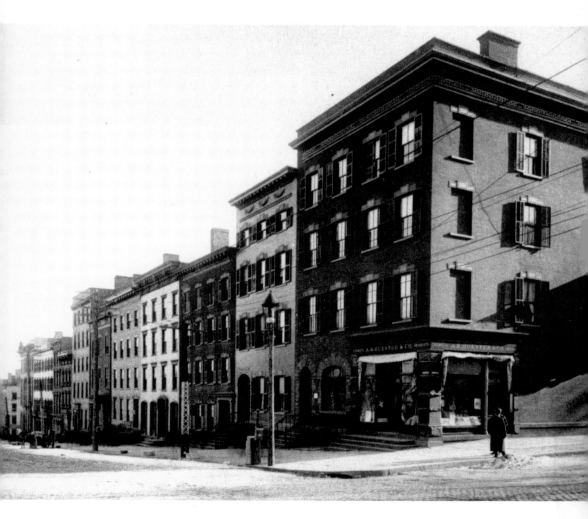

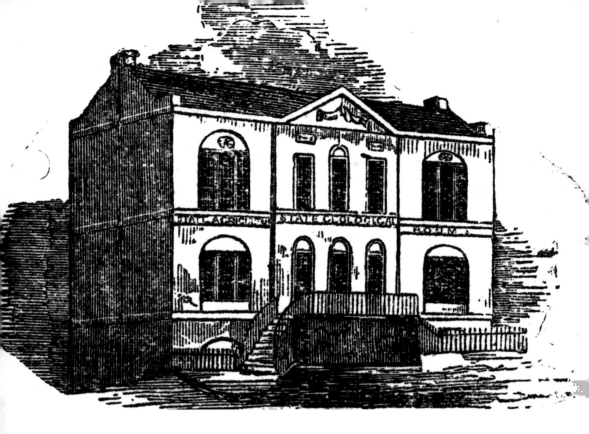

On building: HALL AGRICUL. — STATE GEOLOGICAL ROOM

State Hall was built on the corner of State and Lodge Streets in 1797. It became a museum for the State Geological Corps, now the New York State Geological Survey.

In 1855, State Hall was razed and replaced with a new Geological Hall. The new building contained rooms for exhibits of geology and agriculture and became the State Museum of Natural History (now the New York State Museum). On December 8, 1866, it received bones from a mastodon found in Cohoes during excavations for a mill. The mastodon exhibit, which opened on December 23, 1867, attracted large numbers of visitors. Today, 135 years later, the mastodon is on display at the New York State Museum.

Geological Hall was razed, and the site is now occupied by a smaller building, currently being used by a bank.

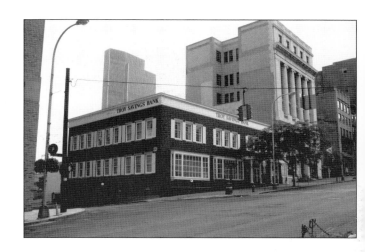

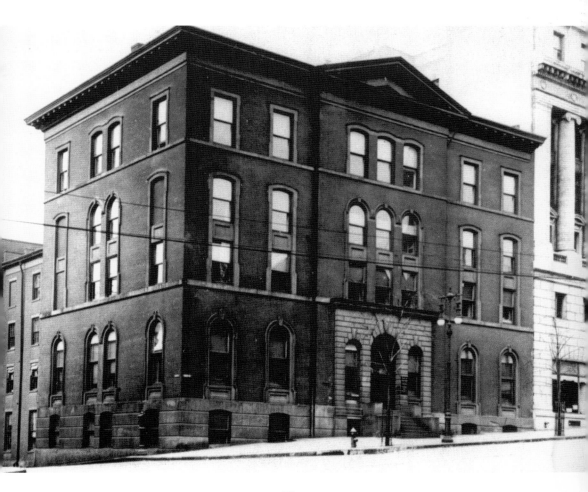

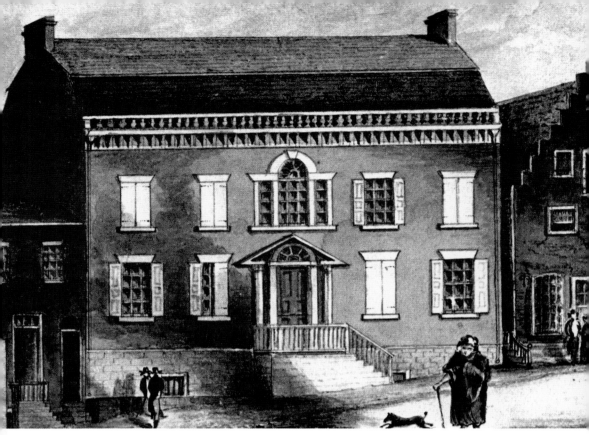

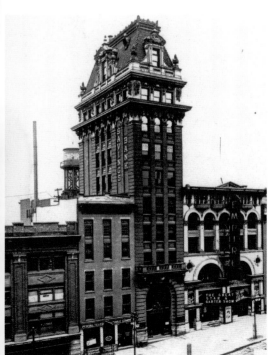

Two historic houses once stood on State Street: the 1780 John Stevenson House and, to its left, the 1716 Harman Wendell House. Both were demolished in 1841

In 1902, the Albany City & County Savings Bank was built on the Stevenson and Wendell lots.

In 1925, the middle and right sections, constructed to match the original building, were added to the bank.. The residence of Erastus Corning stands to the right of the enlarged bank.

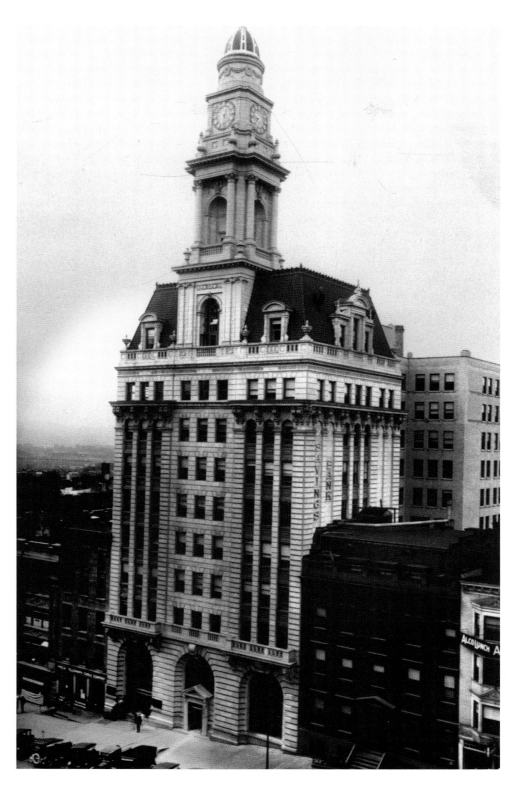

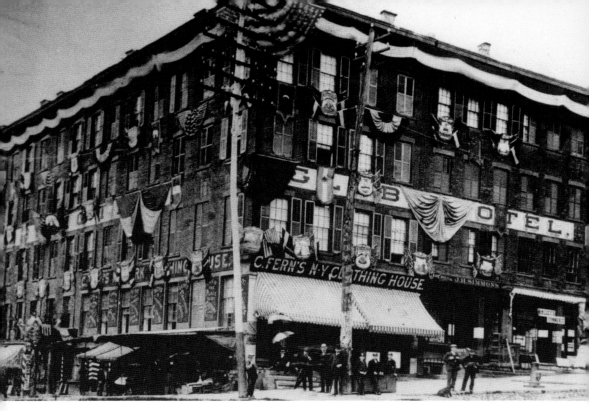

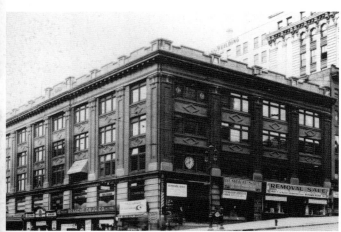

The Globe Hotel, at the southwest corner of State and South Pearl Streets, is decorated for the bicentennial in 1886. The hotel served visitors with retail stores, as well as rooms.

After extensive renovations, the Globe became the Rose-Kiernan Building (left), commonly called the Arkay (R–K) Building.

Later, the Rose-Kiernan Building was replaced by the National Savings Bank (right). Erastus Corning, whose house was only a few doors away, was president of the bank in 1868 when it incorporated and served at 59 State Street.

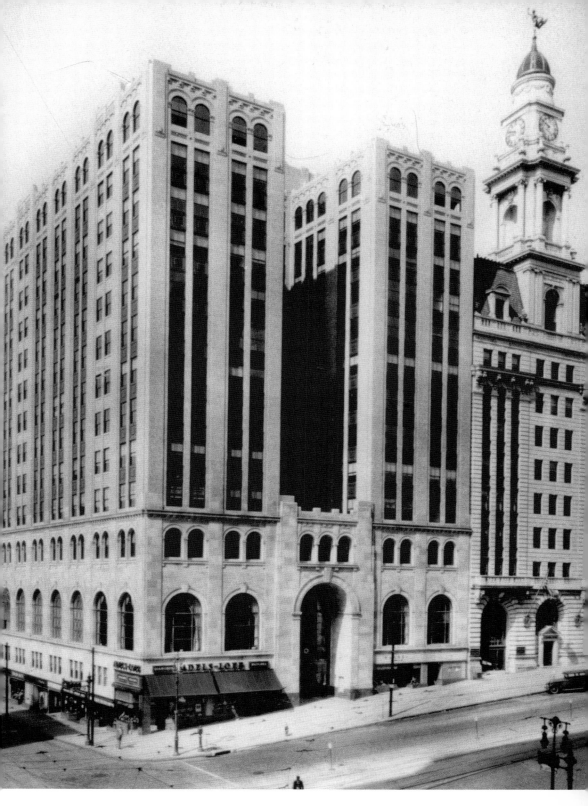

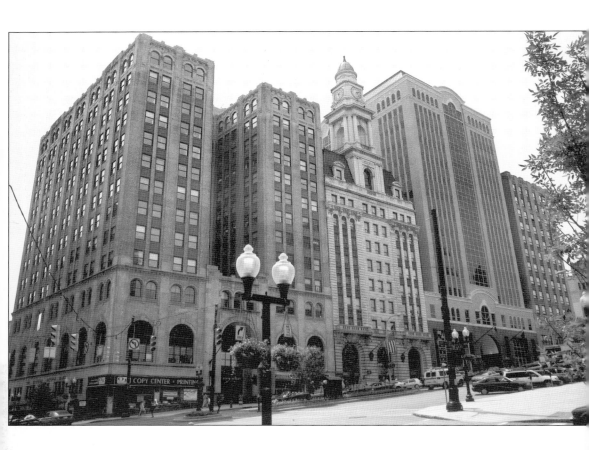

Albany's Skyscraper Row covers the area formerly occupied by small Dutch homes of the 17th century. The row includes the National Savings Bank building, the Albany City & County Savings Bank, the New York State Comptroller's Office Building, and the 1928 Art Deco commercial building.

Just south of Skyscraper Row is South Pearl Street. Many 19th-century commercial and retail establishments made this a busy street.

South Pearl Street today exhibits very little evidence of earlier times. The street has been transformed with parking garages, office buildings, and an entertainment complex.

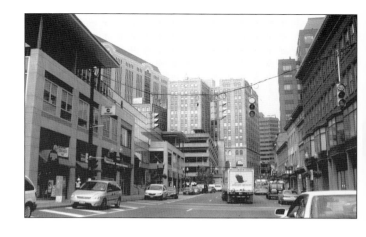

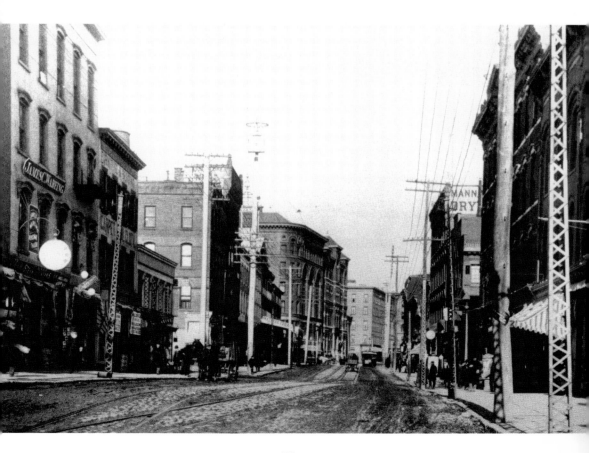

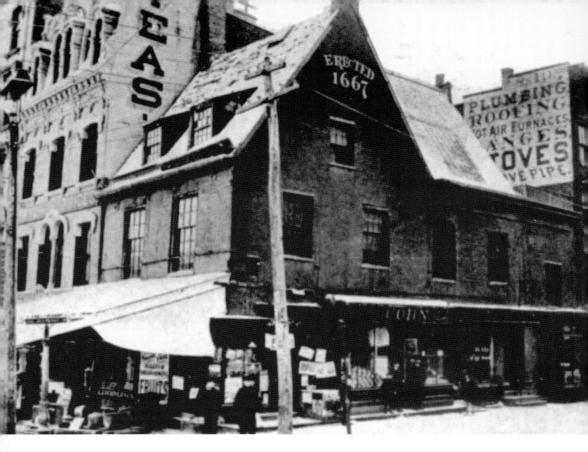

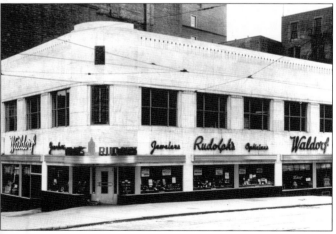

Erected in 1667, the house at the southeast corner of State and Pearl Streets has been erroneously attributed to Abraham Staat. It was actually the home of John Schuyler Jr. and was built by his father, Philip Pietersen Schuyler, father of the first mayor of Albany. One of Albany's last surviving Dutch buildings, it was torn down during the city's 1886 bicentennial.

In 1924, the Schuyler House was replaced with the multistory Albany County Savings Bank (upper right).

The Savings Bank was replaced with an Art Deco restaurant and jewelry store (left) *c.* 1928.

The glass building was erected in the 1980s. Ironically, it mirrors the facade of the 1805 State Bank, on the other side of the street.

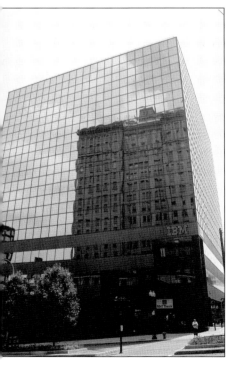

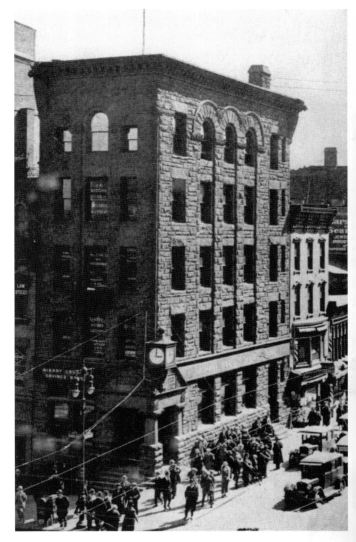

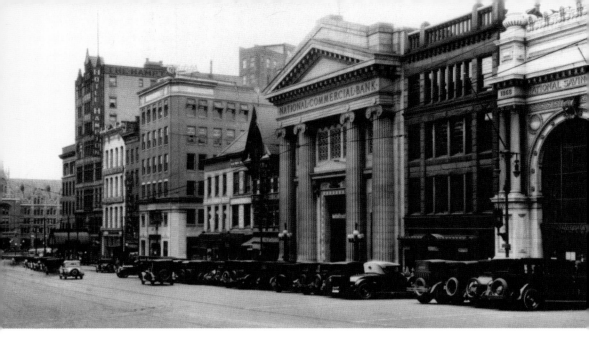

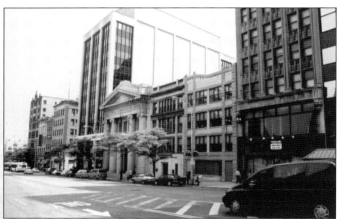

Shown on the south side of lower State Street, from right to left, are the National Savings Bank, the National Commercial Bank building, Keeler's Restaurant, and Jack's Restaurant, established in 1913.

Today, five of the eleven buildings shown above are gone. Jack's, to the right of the last tall building (the old Hampton Hotel), is still serving excellent meals.

ot only have individual pieces of history been lost but also whole sections of the city have been wiped from the landscape.

In this view of Albany, looking south from the Telephone Building, the Albany Hospital is the large domed building in the lower left, flanking Howard and Eagle Streets, which run to the right. The Market Block is the long building in the center.

MAJOR VIEWS

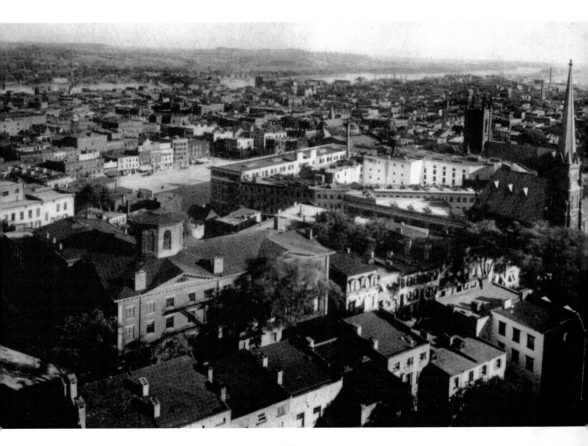

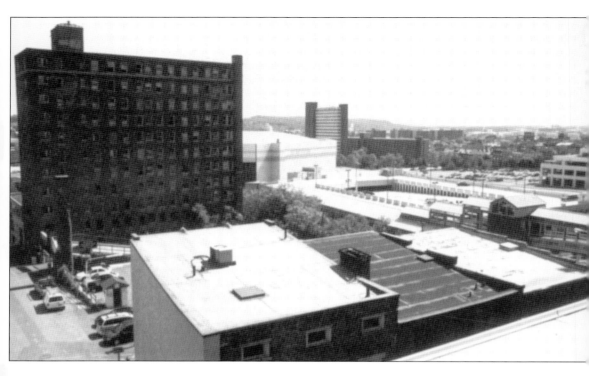

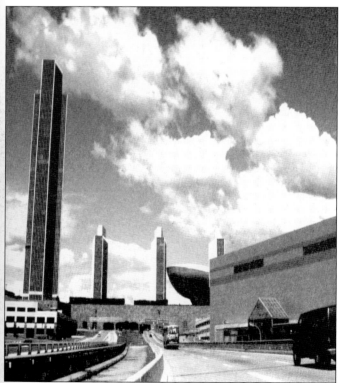

In today's view, the hospital site is now a parking lot, as are areas to the right. (The hospital is now moved and become Albany Medical Center.) The arterial to the Empire State Plaza is out of view but runs between the parking garages in the right half of the photograph.

Commuters have to park their vehicle for eight hours a day while they work. Thus, blocks of homes and businesses have been removed to make more parking space. The eastern entrance to the Empire State Plaza (left) was once the site of numerous buildings.

The *c.* 1915 scene shows the view from the north tower of the Cathedral of Immaculate Conception. In sight are the neighborhoods from Madison Avenue to Howard Street, including the capitol, the telephone company (the large white building), and city hall, to the right.

The current photograph was taken from the same cathedral tower. Thousands of people were displaced as the state of New York, with the blessing of the city, built this complex of office buildings and monuments. The Empire State Plaza replaced neighborhoods with commuters.

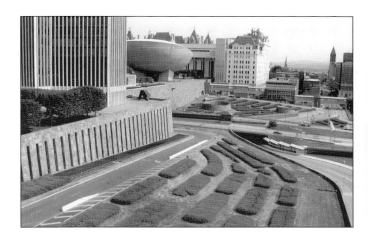

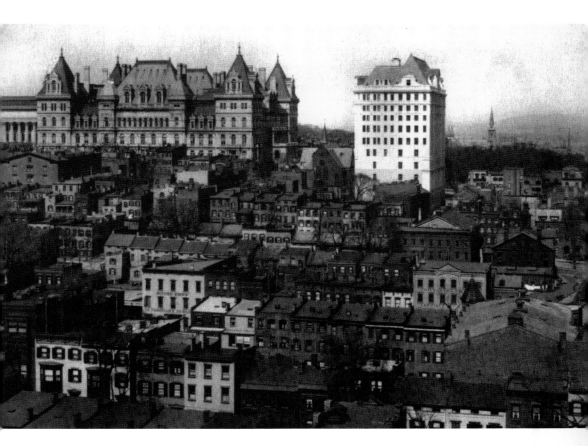

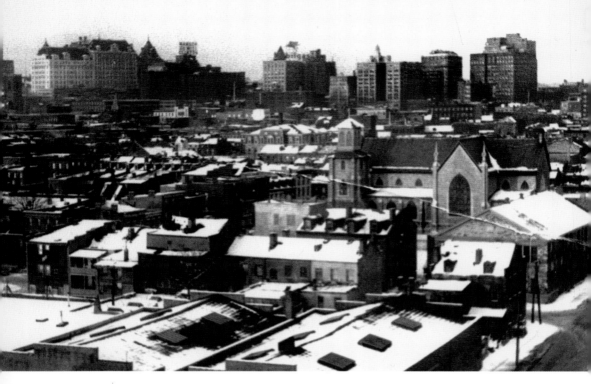

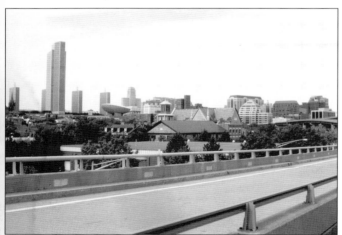

The 1950s photograph of Albany's south end was taken from Dunn Memorial Bridge (since demolished). The original St. Paul's and St. John's Churches are in the middle right, and downtown is in the distance.

Today's view shows ramps from the Interstate 787 system, with the Empire State Plaza looming in the background. The skyline has changed considerably. The structure that resembles a satellite is the Egg, a performing arts center at the plaza. Both St. Paul's and St. John's can still be seen but are no longer in use.

The city was cut off from the river in the 1970s. This *c.* 1920 view shows the D & H Building from the Rensselaer side.

Chapter 8

RIVER VIEWS

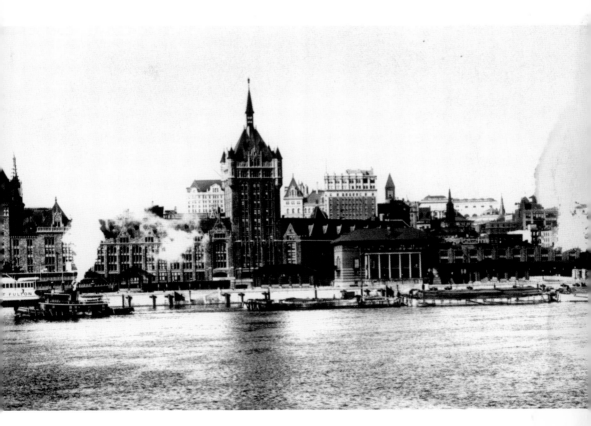

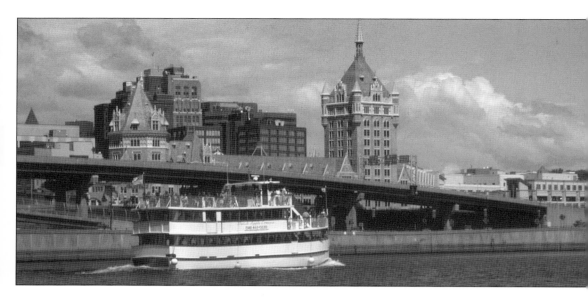

Today, the view is obscured by ramps of the Interstate 787 system. Parking garages line the western side of the highway. The mass transformation of the riverfront into a large arterial system literally cut off the citizens from their historic roots. To help bring back the connection, the city has built a $9 millio pedestrian bridge that crosses into the Corning Preserve. The bridge opened in August 2002.

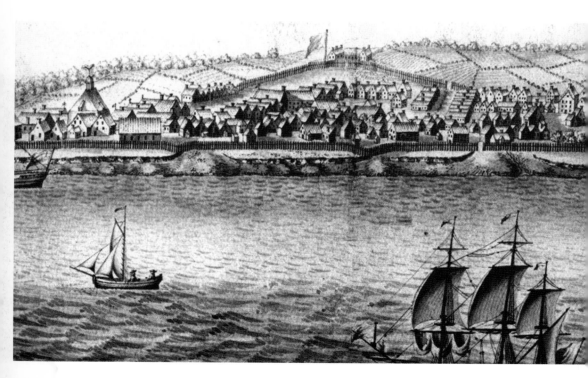

The three other views on these two pages span 310 years. The 1692 view of Albany (lower left) shows the residential flavor of this frontier city during the 17th century, surrounded by a protective stockade to keep the residents within safe from possible attack.

In 1845 (below), the 19th-century city bustles with government and industrial activities. The river is still the dominant mode of travel, as sloops and steamboats ply north and south.

Today (right), the skyline of Albany is still one of style and beauty. However, it represents not a city of industry and prosperity but one of transformation and suburbanization, with parking garages, roads and ramps, and cars and trucks.

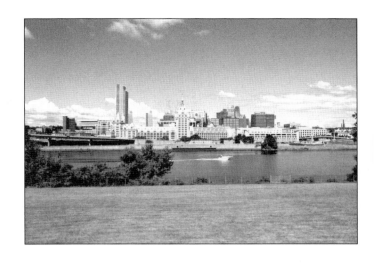

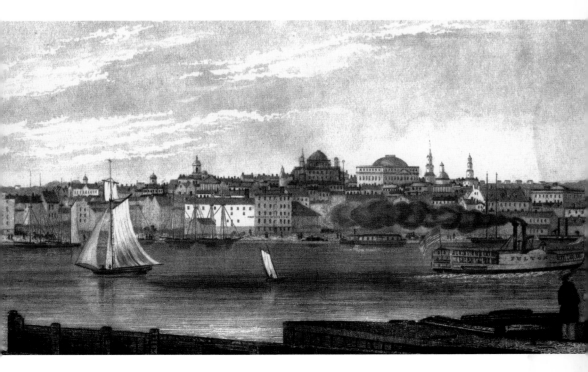

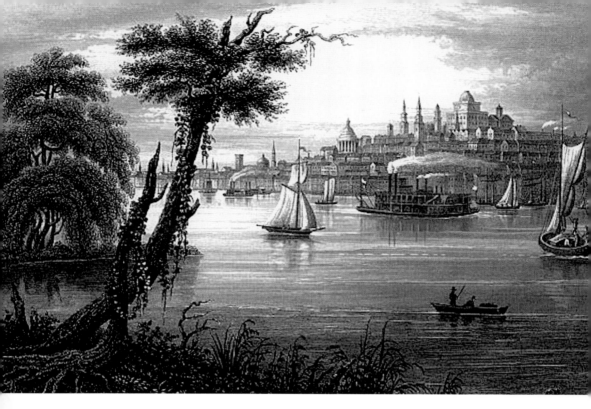

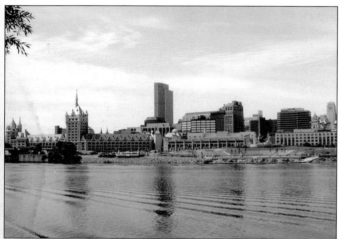

Many 19th–century artists found the view of Albany from Rensselaer one of beauty. This painting shows the city on the hill, with its government and church buildings and various types of river transportation.

Today, the view is still one of style, but river travel has been replaced by highway travel.

Well into the 20th century, Steamboat Square, on lower Broadway between State and Madison Streets, was the point of arrival and departure for many citizens. The view is from across the river in Rensselaer. Steamboat Square is now the point of entry and departure for thousands of motor vehicles each day. The Empire State Plaza looms in the background, and the capitol can be seen at the right.

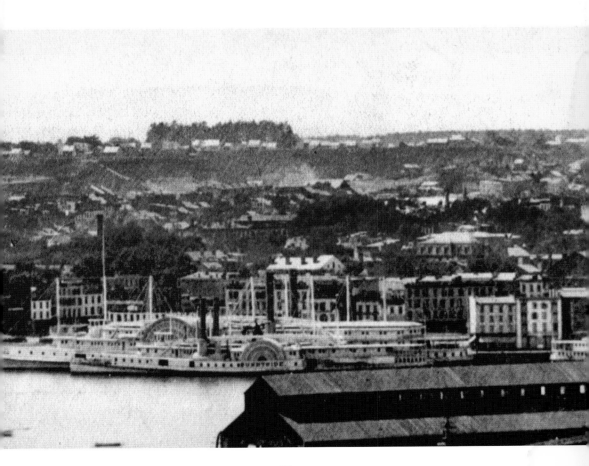

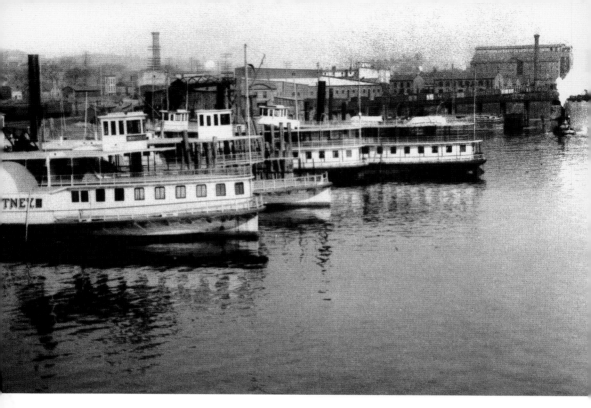

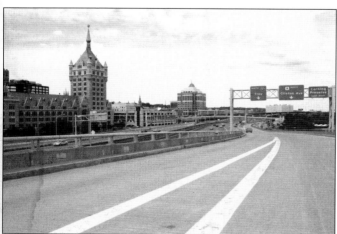

The Sloop Lock and Albany Basin were the commercial lifeblood of th city until the 1870s. Taken from the Sta Street Bridge, the early photograph show the lock and basin with the Maiden Lan Railroad Bridge in the background.

The lock and basin were filled in and covered with the Interstate 787 system during the 1970s.

The early view with the yacht club pier shows the D & H Building in the background. The State Street Bridge and Maiden Lane railroad bridge can be seen on the left.

The view today includes a lot of pavement.

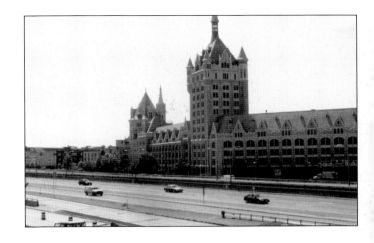

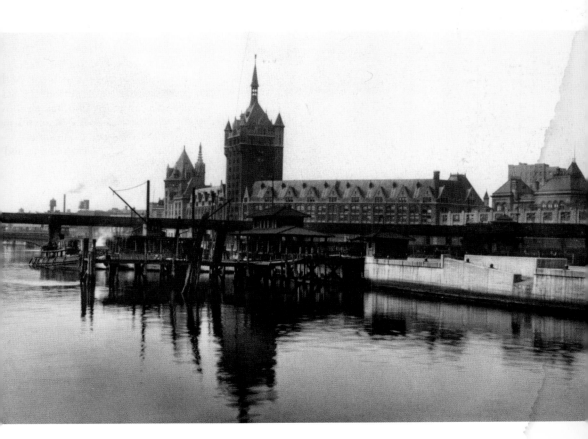

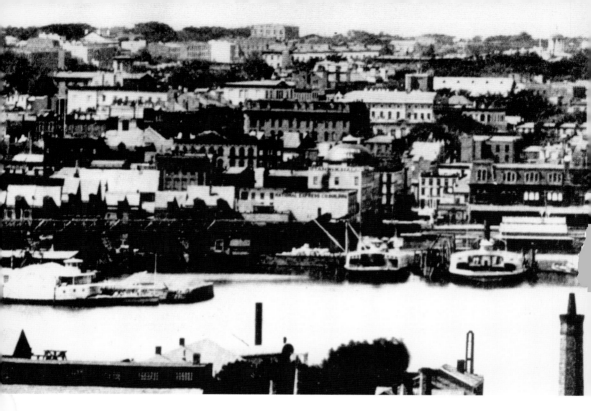

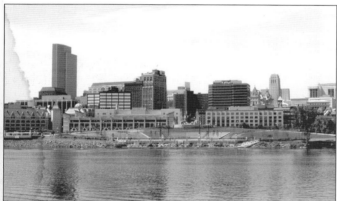

The 1870s view of downtown shows Maiden Lane in the center, Stanwix Hall (the domed building, later a hotel) at the corner of Maiden Lane and Broadway, the original train station (with the mansard roof) on the right on Montgomery Street, and numerous boat lining the basin.

Today, the new Maiden Lane pedestrian bridge brings people back to the river into a large amphitheater, show in the middle. A dock is in place for pleasure craft.

nother 1870s view of downtown
was taken facing Steuben Street.
tice the Delavan House, later the
of Union Station, in the middle.
rehouses line the Albany Basin,
cured by the trees.
n the present-day view, Union
tion, on the site of the Delavan
use, is a bank headquarters. Nothing
has survived.

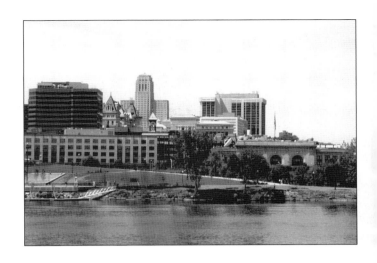

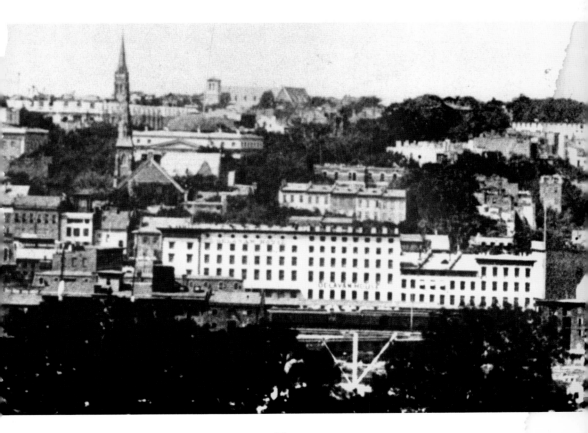

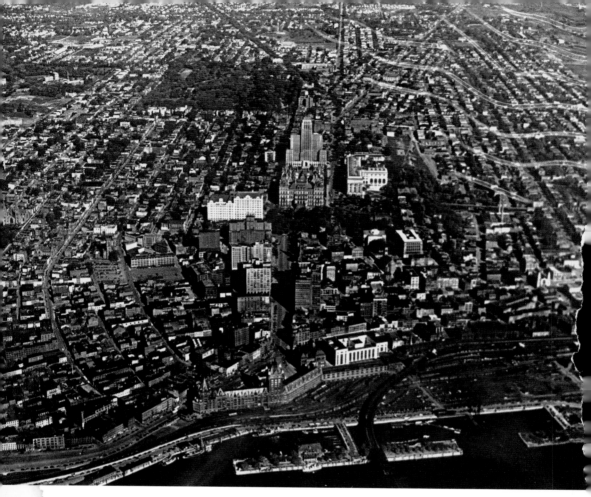

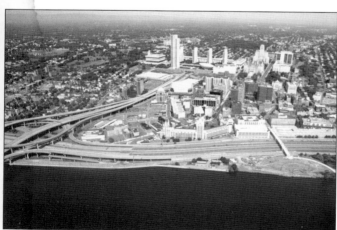

In its heyday during the 1940s, Albany still retained evidence of its 17th-century roots, visible in some of th street patterns.

The recent aerial photograph by Chris Milian shows a city that remains picturesque and remarkable in its history However, whether Albany will honor its historic roots by developing a sound preservation policy to protect standing and buried cultural resources remains to be seen. One can only be optimistic.